PERTH
THROUGH TIME
Jack Gillon

AMBERLEY

Acknowledgements

I'm not sure what the correct demonym (it seems that demonym is a word that identifies residents of a particular place) is for people from Perth – Perthite or Perthian, perhaps. Anyway, a number of them took the time to offer advice as I was taking photos or having a break in one of the many fine refreshment establishments in the city. This gave the lasting impression that Perth is a friendly and welcoming place.

Particular thanks to Diageo for the use of the images of the Bell's factory workers and directors.

Above all, a big thank you to Emma Jane for her her endless help and support.

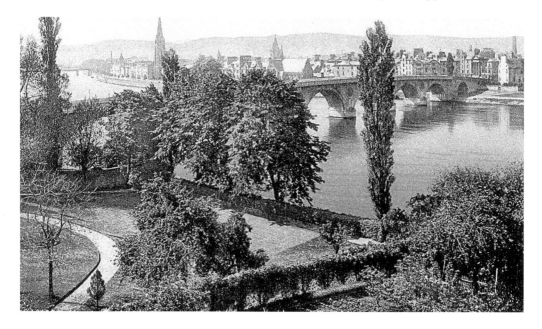

First published 2017

Amberley Publishing
The Hill, Stroud, Gloucestershire, GL5 4EP
www.amberley-books.com

Copyright © Jack Gillon, 2017

The right of Jack Gillon to be identified as the
Author of this work has been asserted in accordance with
the Copyrights, Designs and Patents Act 1988.

ISBN 978 1 4456 6324 1 (print)
ISBN 978 1 4456 6325 8 (ebook)

British Library Cataloguing in Publication Data.
A catalogue record for this book is available from the
British Library.

Origination by Amberley Publishing.
Printed in Great Britain.

Introduction

One would have thought that there was no Perth man (out of the asylum) who would not have rejoiced in his unstained tranquillity, in the delightful heights that enclose him – in his silvery Tay – in the quiet beauty of his green and level Inches.

(Lord Cockburn, *Journals*, 1874)

There is some debate about the origin of the name Perth. It is said to derive either from a Pictish word for wood or copse, or from *Aber-tha* meaning the mouth of the Tay. For centuries Perth was known as St John's Toun, from its association with its church dedicated to John the Baptist.

The location of Perth, at the lowest crossing point of the Tay, was fundamental to its development and it has been inhabited since prehistoric times. Its location close to Scone, with its royal connections, was an important factor in the growth of the settlement. It was the effective capital of Scotland until the mid-fifteenth century and an important religious centre.

Perth was given royal burgh status in the early twelfth century under David I and developed as one of the most affluent towns in Scotland. The navigable River Tay was a significant factor in the prosperity of the town as ships could sail up the river and the harbour carried out an extensive foreign trade. Perth was also a thriving industrial base for leather, linen and metalwork.

Perth, however, suffered its fair share of troubles from invading armies, outbreaks of the plague and destructive floods.

In the nineteenth century, whisky production, insurance and dyeing were additions to Perth's traditional industries and burgeoning economy. The first railway station in Perth

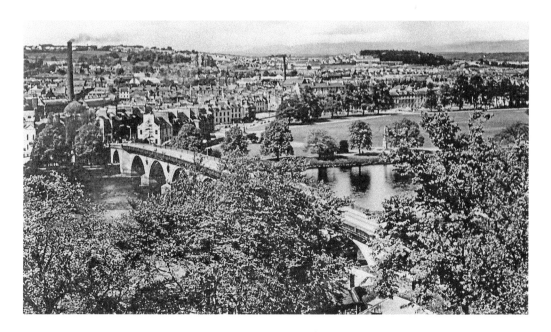

opened in 1848, further enabling expansion, and the city became known as the 'Gateway to the Highlands'.

An outward sign of this growing prosperity was the 'improvement schemes of considerable magnitude which were adopted and carried out' – new grid-plan developments of elegant Georgian terraces to the north and south sides of the town were built and the old medieval layout of the town was rationalised.

Perth has been known for centuries as the 'Fair City'. However, in the late 1990s the government decided that it no longer met the criteria for city status. This was rectified on 14 March 2012, as part of the Queen's Diamond Jubilee celebration, when Perth was reinstated as an official city.

Perth is central to Scotland and its history, and today it is a charming historic city that retains much of its ancient character and architectural quality. Modern-day Perth is a thriving place; its retail centre has an attractive pedestrianised high street and a wide variety of shops, cafes, museums, galleries, restaurants and pubs.

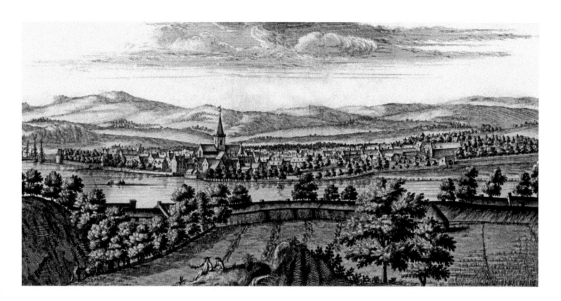

Perth Views

The older image dates from 1693. This was a time when there was no bridge over the Tay at Perth and a ferry boat can be seen at the crossing point. The most prominent building is St John's Church and boats are moored at the harbour that, at the time, was closer to the town.

St John's Church is still prominent in the more recent image from the early 1900s, which also shows Perth's three bridges and what would, at the time, have been the fairly recently formed Tay Street. It also presents a more industrial aspect than today with tall chimneys serving factories and mills in the town.

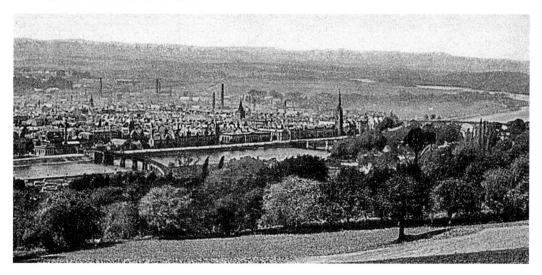

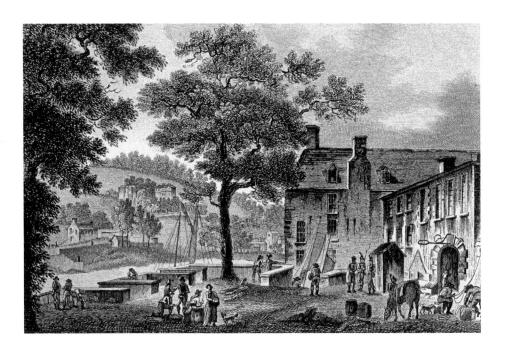

Perth Harbour

Perth is located at the highest navigable point on the Tay and the town was an important harbour from medieval times. The harbour was originally closer to town at the foot of the High Street – the older print shows the harbour at the North Shore in around 1800. The tolbooth at the foot of the High Street was a customs point, a civic meeting place and a prison – it was demolished in 1839. As the river silted and ships became larger, the harbour moved further downstream. A number of small shipyards also operated in the harbour area until the decline of the business in the late nineteenth century.

The present harbour at Friarton was constructed in 1840 to a design by Robert Stevenson. Financial difficulties, partly due to the emergence of the railways, delayed completion – further quays were added in 1898 and 1939. The harbour continues Perth's long tradition as a port.

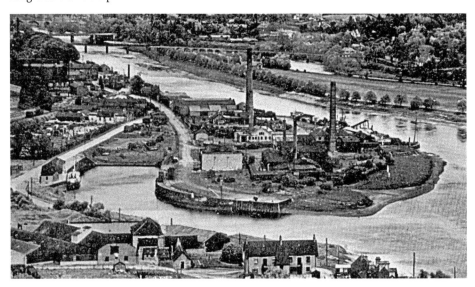

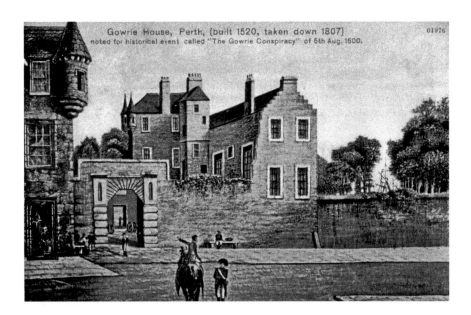

Gowrie House, Perth, (built 1520, taken down 1807)
noted for historical event called "The Gowrie Conspiracy" of 5th Aug. 1600. 01976

Gowrie House

Gowrie House was built for the Countess of Huntly in 1529 and stood at the end of the present South Street. It was one of Perth's grandest and most celebrated buildings. It was later purchased by Lord Ruthven and passed to the city of Perth after the murder of the Earl of Gowrie. In 1746, it was presented to the Duke of Cumberland who sold it to the government, and it was used for many years as artillery barracks. It was demolished in 1807/09, for the extension of South Street to the River Tay and to make space for the County Buildings.

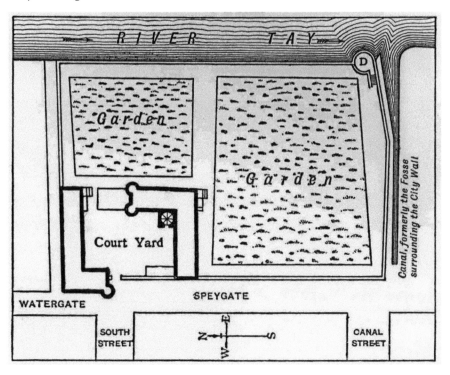

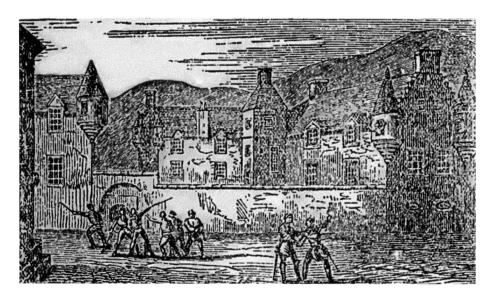

The Gowrie House Conspiracy

The 5th of August was once celebrated as a holiday in the same way as the 5th of November, for a similar reason involving Gowrie House. On that day, in 1600, James VI narrowly escaped death at the hands of the Earl of Gowrie and his brother, Alexander Ruthven, at Gowrie House. The earl and his brother were both killed in the incident and the king's young page, John Ramsay, who came to his rescue, was the hero of the hour.

It was a confused affair and this account of the events was not unanimously believed. A Royal plot to remove the Ruthvens was suspected; the king was in debt to the Ruthvens and they were supporters of Queen Elizabeth, who was overtly hostile to the Scottish king.

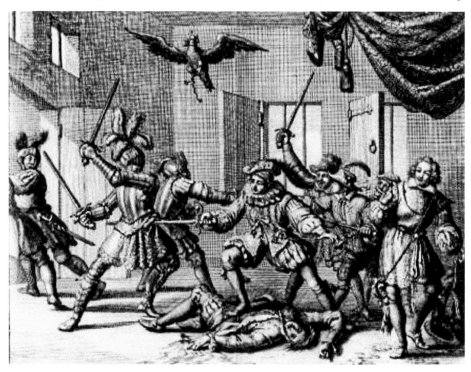

Town Wall Ports

In 1296, during the Wars of Independence, Perth was held by the army of Edward I. The English fortified the town with a wall in 1304. This remained until Robert the Bruce's recapture of Perth in 1312, when he ordered its removal. In 1336, Edward III again ordered the construction of a town wall with the intention of making Perth an English stronghold.

There were several gates, or ports, in the wall. The walls were demolished in the second half of the eighteenth century, and there are now no visible remains.

The wall followed the line of the town lade, originally a source of power for the town's mills, and acted as an additional line of defence. The lade has its source at a weir on the River Almond near Huntingtower and is now mainly culverted but is still open at points around the town.

Perth also had a castle, located to the north of the old burgh, defending the medieval bridge. It was built of timber and was destroyed by floods in 1209.

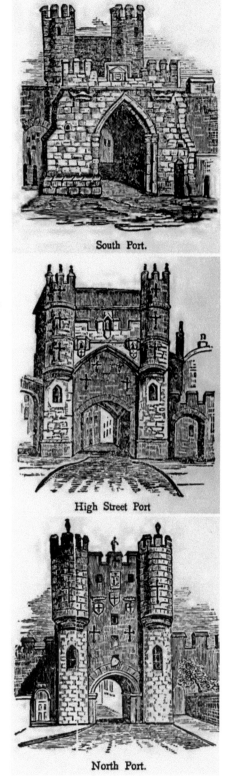

South Port.

High Street Port

North Port.

9

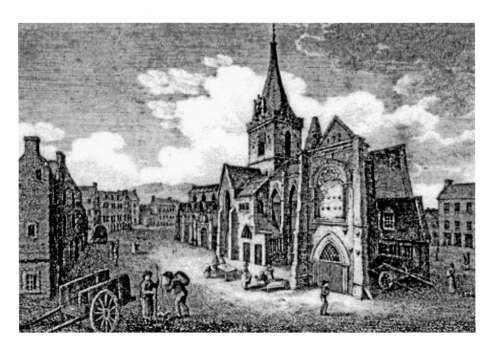

Church of St John the Baptist I

The Church of St John the Baptist is Perth's oldest surviving building. The original church was completed by 1241, although most of the present structure dates from between 1440 and 1500. However, there are references to a well-established church dedicated to St John the Baptist in Perth as early as 1128. The church was so central to life in Perth that the town was at one time known as St John's Toun.

By 1715, three different congregations were using the subdivided building and there followed a long period of neglect. In 1923, the church was extensively renovated and restored by Sir Robert Lorimer as a memorial to the people of Perth who sacrificed their lives in the First World War.

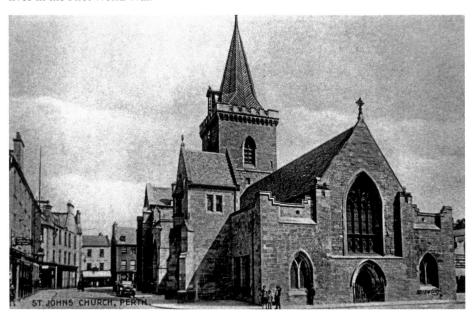

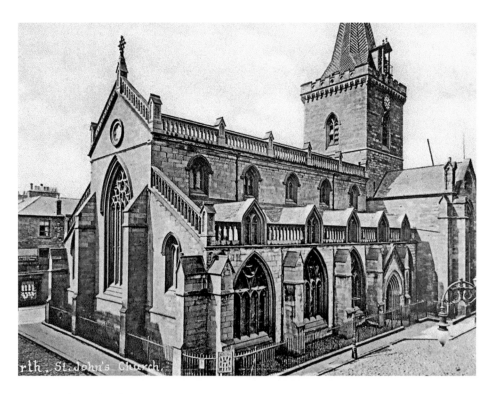

Church of St John the Baptist II

On 11 May 1559, John Knox preached a provocative sermon against idolatry at St John's; it so inflamed the congregation that they smashed the altars in the church and went on to sack the monasteries in the town. The events were the starting point of the Scottish Reformation.

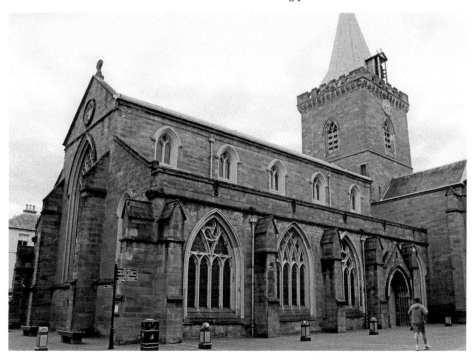

THE CARTHUSIAN MONASTERY OR CHARTERHOUSE

THE DOMINICAN OR BLACKFRIARS MONASTERY

THE CARMELITE MONASTERY OF PERTH.

THE FRANCISCAN OR GREYFRIARS MONASTERY

Perth's Monasteries

> The Charterhouse toward the south-west stood,
> And at south-east the friars who wear grey hood.
> Toward the north the Blackfriars Church did stand,
> And Carmelites upon the western hand.
>
> (Lines on the Monasteries,
> *Muses Threnodie*)

The Dominican Monastery was founded by Alexander II in 1231 and was situated at the north end of Blackfriars Wynd. James I was murdered in the monastery on the night of 20 February 1437 by followers of the Earl of Atholl. The Carmelites or Whitefriars Monastery at Riggs Road was founded by Alexander III in 1262. It was the first settlement of Carmelites in Scotland. The site of the Carthusian, or Charterhouse Monastery, is marked by a monument at the corner of Hospital Street and King Street. It was founded in 1429 by James I and was Scotland's only Carthusian monastery. It was described as the 'most sumptuous building that adorned Perth'. Perth's Franciscan or Greyfriars monastery was founded in Perth before 1496 – the site became the town cemetery in 1580.

Perth's four monasteries, which were described as a 'great addition to the architectural features of the city', were all swept away during the Reformation.

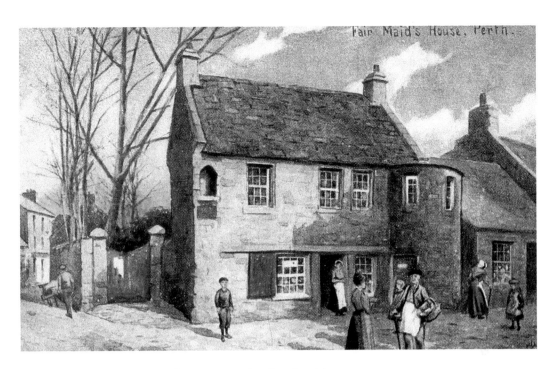

Fair Maid's House, North Port Street (Curfew Row) I

The Fair Maid's House has fifteenth-century origins and is the oldest surviving non-religious building in Perth. The building was purchased by the Glover Incorporation of Perth in 1693 and the upper flat was converted into a hall, which they used as a meeting place for 150 years.

The house takes its name from Sir Walter Scott's 1828 novel *The Fair Maid of Perth*, in which the building features as the home of Catherine Glover, the Fair Maid. Perth has been known as 'The Fair City' since the publication of the novel.

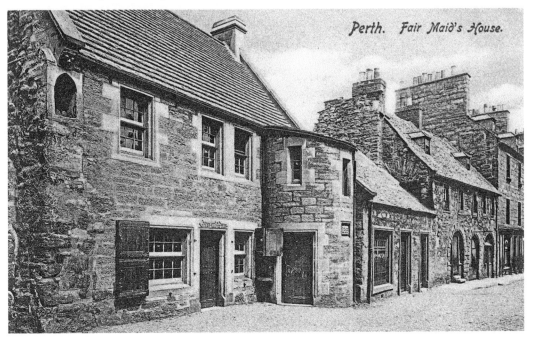

Perth. Fair Maid's House.

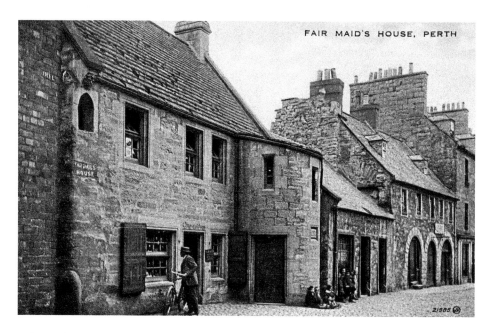

Fair Maid's House, North Port Street (Curfew Row) II

A head is carved on the gable end with the motto of the Glovers, 'Grace and Peace', over the house door. The niche on the outside is said to have contained the curfew bell or a statue of St Bartholomew, the patron saint of the Glovers. A plaque on the adjoining building notes that it was the site of the town house occupied by Lord John Murray, MP for Perthshire from 1734–61, who was appointed General of HM Forces in 1770. Both buildings are now occupied as a centre for geographical and environmental education by the Royal Scottish Geographical Society.

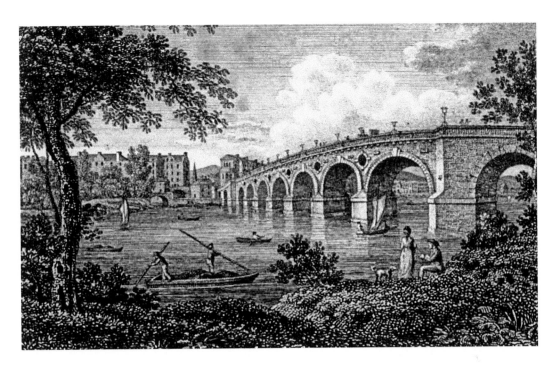

Perth Bridge I

Until the nineteenth century, Perth was the lowest crossing point of the Tay. In 1209, a bridge at the foot of the High Street was swept away by floods. It was rebuilt soon afterwards and there are records of repairs being made to it in the ensuing centuries. However, by the end of the sixteenth century it was clear that a new bridge was needed. In 1604, John Mylne, the king's master mason, was commissioned to design a new crossing. This opened in 1616, but was washed away during three days of violent storms in 1621. For the next 150 years there was no bridge, and crossings of the Tay were made by ferry boat services, which could be hazardous in the fast-flowing waters of the river. The new bridge opened in 1771 and the prosperity that it brought to Perth is made clear by the spate of new development that can be seen in the background of the image below.

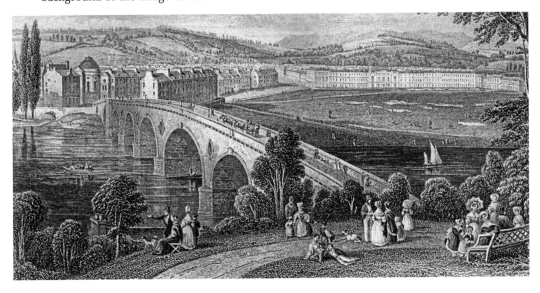

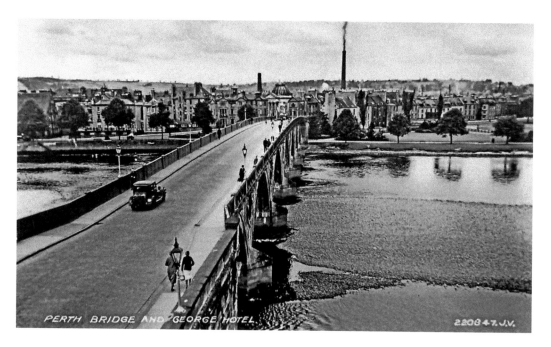

PERTH BRIDGE AND GEORGE HOTEL

Perth Bridge II

The idea for a new bridge crossing was promoted by Thomas Hay, 9th Earl of Kinnoull (1710–87), and in 1765 an Act of Parliament approved the construction of the bridge. The eminent engineer John Smeaton (1724–92), who is regarded as the 'father of civil engineering', was appointed to design the bridge, which was completed in October 1771.

Smeaton's elegant, local-sandstone nine-arch bridge was, at 272m (893ft), the longest in Scotland when it opened. It cost £26,631, which was met by the government from seized Jacobite funds and public subscriptions. A halfpenny toll was charged until 1883 and the old toll house can still be seen at the Bridgend side of the bridge.

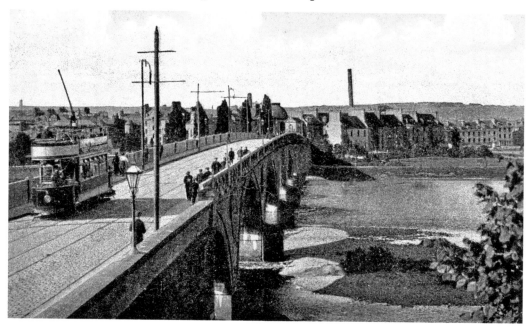

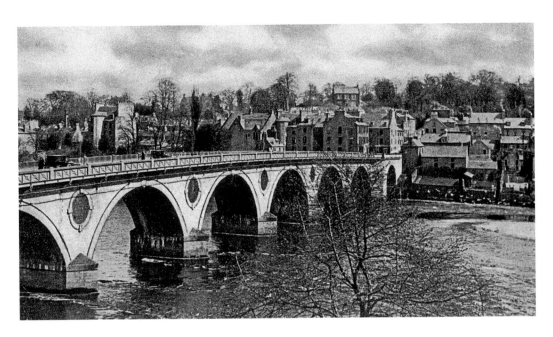

Perth Bridge III

The Bridge was designed to withstand the highest-level spates on the Tay and was tested some three years after it opened when ice blocked the river and parts of the town were flooded. The bridge stood firm and has survived many subsequent floods. The river levels during floods are recorded on the north face of the bridge's pier. The bridge was widened in 1869 to cope with increased traffic – the stone parapets and cast-iron cantilevered footpaths were added at that time.

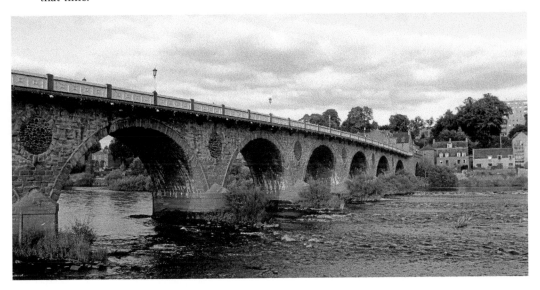

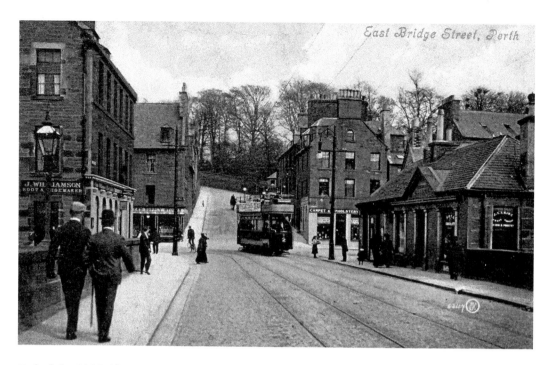

East Bridge Street, Perth

End of the Old Bridge

The older image shows a tram manoeuvring around the corner onto the bridge. The single-storey building on the right was the old bridge toll house. A sign, dated 1879, on the outside of the building specifies the rules for locomotives crossing the bridge:

'Be it enacted that no locomotive shall pass upon or over Perth Bridge between the hours of 10am and 3pm and that at other times the person in charge of such locomotives shall send a man with a red flag to the opposite end of the bridge from that on which he is to enter, warning all persons concerned of the approach of the locomotive before it shall go upon the bridge.'

The penalty for breaching the by-law was £5 for each offence. The building behind the toll house in the older image has been demolished in the intervening years.

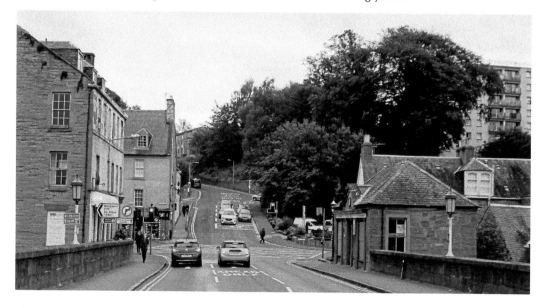

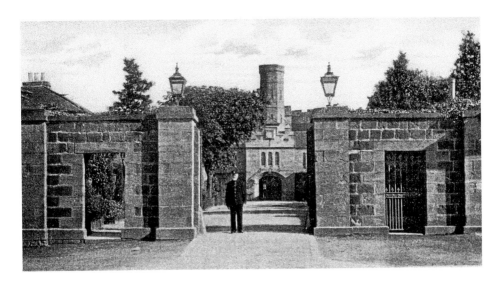

Perth Prison

Perth Prison was built between 1810 and 1812 to accommodate French prisoners captured during the Napoleonic War. The design was by the eminent architect Robert Reid (1774–1856). There was a huge turnout to witness the first group of 400 prisoners arriving in Perth and up to 7,000 French prisoners were housed in the building at its peak. Conditions were fairly basic, with hammocks for sleeping. However, it seems that the prison regime was generally fairly relaxed – the prisoners ran a market open to everybody and the officers were even allowed to stay with local families, provided they promised not to escape. The French prisoners were returned to France after the Battle of Waterloo in 1815 and a large crowd of locals gave them an emotional send-off. Between 1815 and 1839, the building was used as a military clothing store. In 1840, it became a civilian prison and is the oldest prison still in use in Scotland.

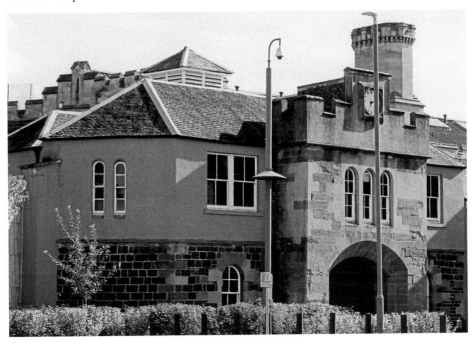

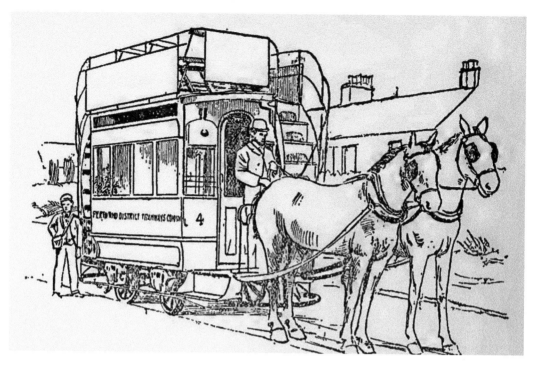

Perth's Horse-drawn Trams

The horse-drawn tram service of the Perth and District Tramways started on 17 September 1895 with a line from Perth to Scone. In October 1903, the horse tramways were taken over by Perth Corporation Tramways. The card commemorating the last running of the horse-drawn trams reads: 'In Affectionate Remembrance of the Perth Horse Cars', 'They did their work their day is done' and 'Ring out the old Ring in the new'.

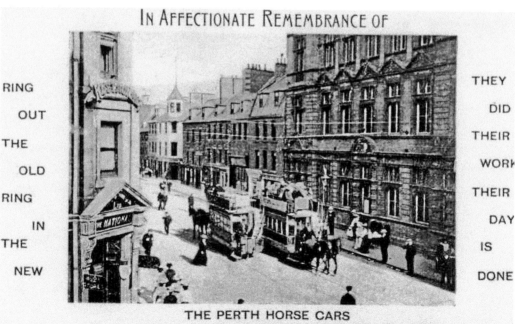

IN AFFECTIONATE REMEMBRANCE OF

RING OUT THE OLD RING IN THE NEW

THEY DID THEIR WORK THEIR DAY IS DONE

THE PERTH HORSE CARS
WHICH SUCCUMBED TO AN ELECTRIC SHOCK ON TUESDAY OCTOBER 31st 1905

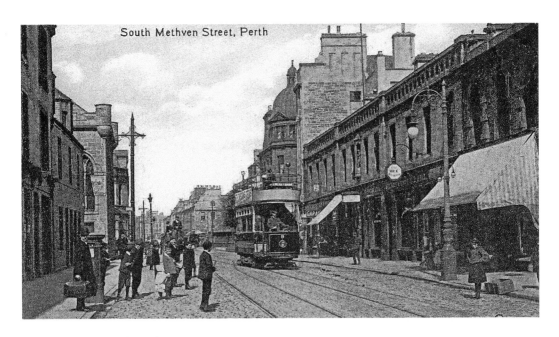

South Methven Street, Perth

Tram on South Methven Street

An electric tram service began in Perth on 31 October 1905 – there was a festival atmosphere on the day, with eager crowds turning out for a first view of the new vehicles. In the evening, an illuminated tram with a band on board toured the town. They were hugely popular, with over 25,000 passengers using them in their first month of operation. The trams ran on a single track with loops to allow the trams to pass. The main route was from Scone to Cherrybank with branches to Craigie and Dunkeld Road. The Perth trams closed on 19 January 1929 and were replaced by bus services.

South and North Methven Street followed the line of the town lade and was Perth's historic western boundary.

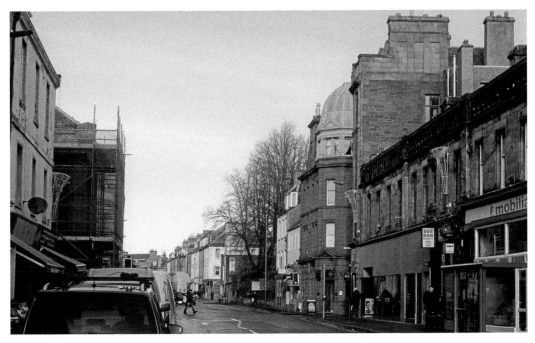

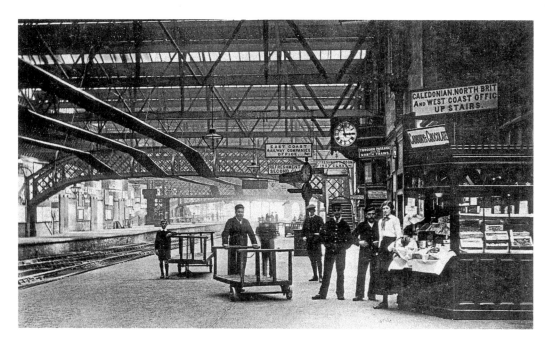

Perth Railway Station

A group of station workers eagerly await travellers in the older image of Perth railway station. Perth railway station was opened in 1848 by the Scottish Central Railway. The station was extended in 1866 and largely reconstructed in 1886. John Menzies opened one of its first bookstalls at Perth Station in May 1857.

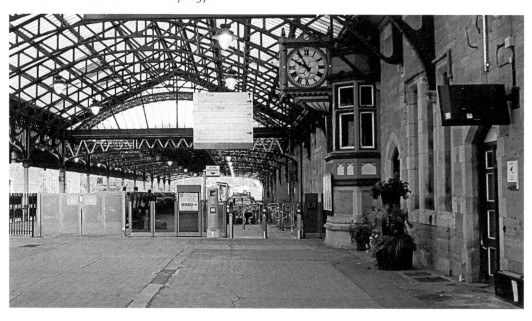

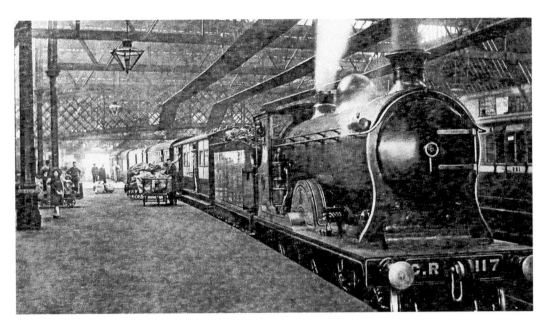

Trains at Perth Station

Perth railway station developed as a main hub on the Scottish rail service. The top image shows the 5.45 p.m. London postal train about to leave the station in 1914. The lower image shows the 12.15 p.m. Carlisle Express, again in 1914.

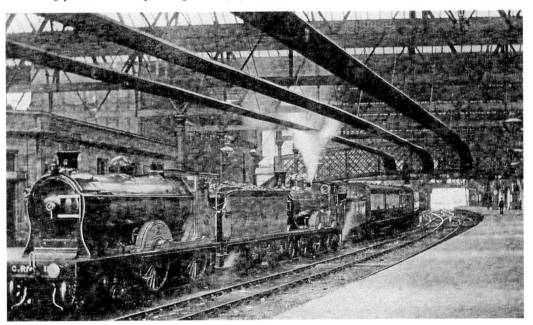

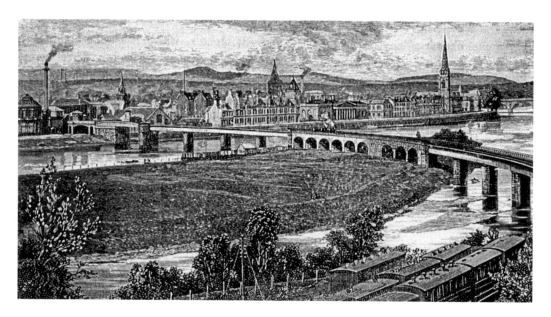

Perth from Barnhill I

The rail service from Dundee to Perth began in 1827, but terminated at Barnhill on the east side of the river until a wooden railway bridge across the Tay was opened in 1849. There were problems with the foundations of the old bridge and the safety of its timber construction must have worried a few train passengers. The replacement bridge was designed by the engineers of the Caledonian Railway and opened in 1862.

The view of the railway bridge from Barnhill is one of the most ubiquitous images of Perth in historic prints. It is a particularly charming vista with Moncrieffe Island in the foreground and Tay Street in the background.

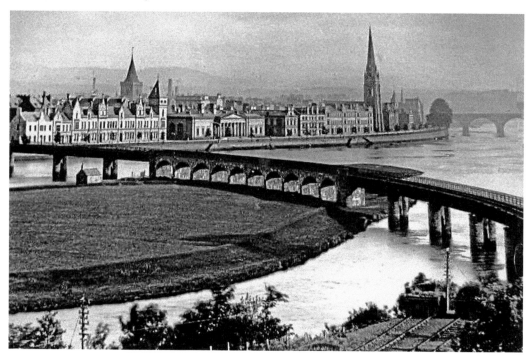

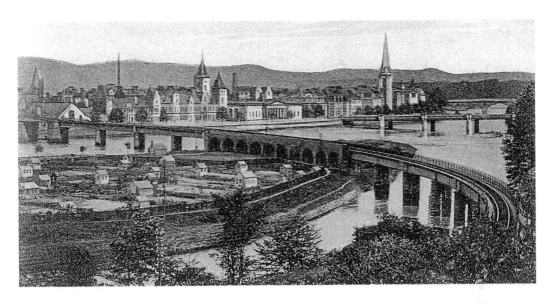

Perth from Barnhill II

The railway bridge is a composite structure with iron-girder spans to the east of Moncrieffe Island, a central solid masonry section of ten stone arches on the island, and more girder spans to the west. It was one of the first large plate-girder bridges in Scotland. The southern most span could originally be opened to allow shipping further upstream. A pedestrian walkway runs beside the railway track.

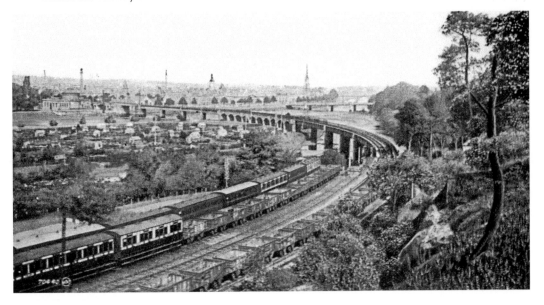

North Inch

'The natural beauty of Perth is greatly enhanced by these delightful recreation grounds, the North and South Inches, and there is probably no other place in Scotland where the inhabitants possess such a precious boon.' (*Perth: the Ancient Capital of Scotland*, Samuel Cowan, 1904).

The North and South Inches were given as common ground for the use of the people of Perth by Robert III in the 1370s. 'Inch' means island or meadow from the Gaelic *innis*. The North Inch has served many functions over the centuries: grazing and cattle markets, bleaching and drying laundry, witch burning, boating, horse racing, golf, rugby, and cricket.

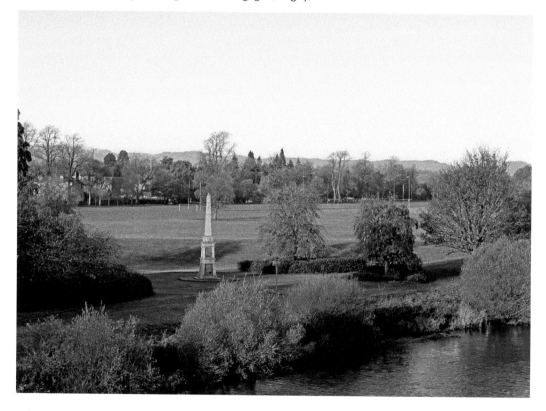

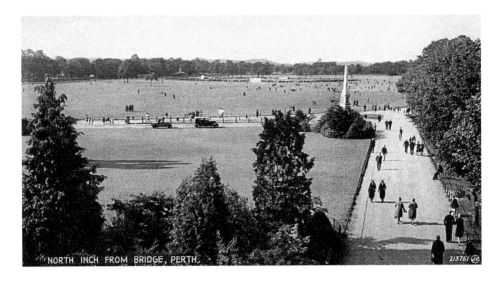

NORTH INCH FROM BRIDGE, PERTH. 2/3761 (JV)

The Battle of the North Inch

The Battle of the North Inch, or Battle of the Clans, was a combat to settle a feud between the Clan Chattan and Clan Kay (or Cameron, or Davidson – there are different versions of the event). It was fought in September 1396 in front of Robert III.

Thirty men were selected to represent each clan, although just before the battle was about to begin it was discovered that Clan Chattan was a man short. A financial incentive was offered and a local blacksmith, Henry Smith, described as 'small and bandy-legged, but fierce' volunteered to stand in. A fierce battle commenced with the clansmen charging at each other armed with axes and swords. The result was a victory for Clan Chattan who had eleven survivors; all but one of their opponents, who escaped by swimming over the Tay, were killed.

Henry Smith, the local volunteer at the battle, was one of the survivors. Smith was also known as Hal o' the Wynd and the character of Henry Gow in Sir Walter Scott's novel *The Fair Maid of Perth* is loosely based on Smith. An eighteenth-century house on Mill Wynd is known as Hal o' the Wynd House.

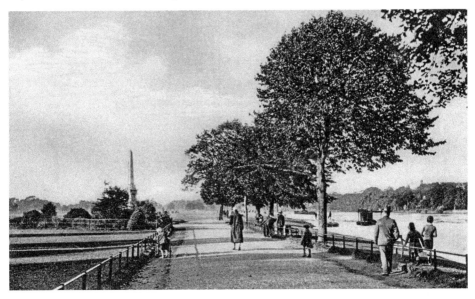

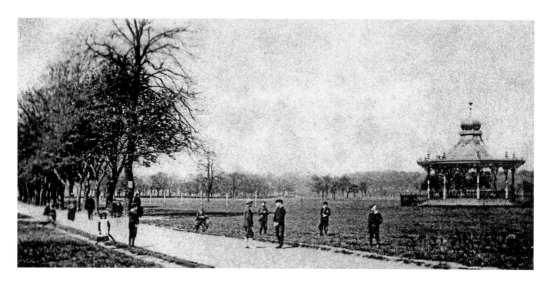

North Inch Bandstand

The bandstand was located on the west side of the North Inch. It was gifted by James Pullar. The opening concert was a performance by the band of the 6th Royal Dragoons on the 25 July 1891. The bandstand was a popular venue during the summer months, with bands providing musical entertainment. In 1959, the bandstand was declared unsafe, demolished and sold for scrap.

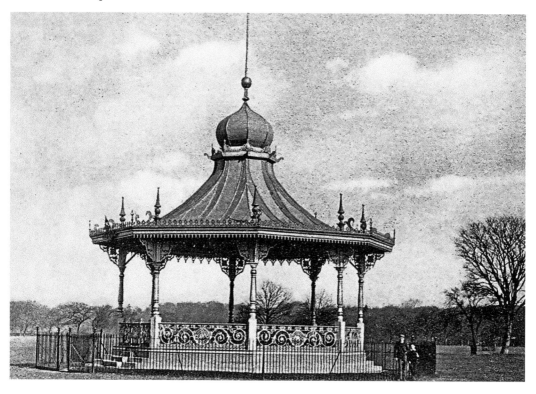

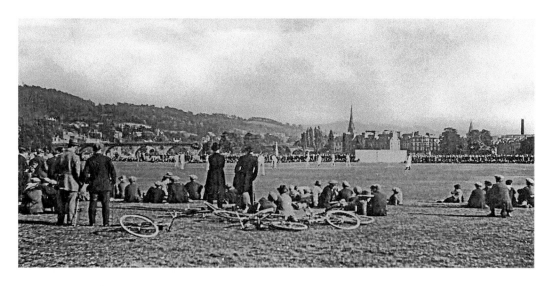

Sport on the North Inch

The North Inch has always been a popular venue for sporting activities. A racecourse ran around the perimeter until it moved to Scone in 1908.

The first of these old images shows a cricket match underway on the North Inch, and the second an unidentified event that has interested a fairly large crowd of spectators. The North Inch was an important venue for cricket – the first recorded match was in 1849.

The North Inch golf course had six holes in 1803, which was increased to eighteen by Old Tom Morris in 1892. The North Inch hosted the Open in 1864 and 1866. In 1861, golfers took exception to trees, which had been planted on the North Inch by the council and interfered with their game – a mob of enraged golfers marched to the Inch and uprooted them.

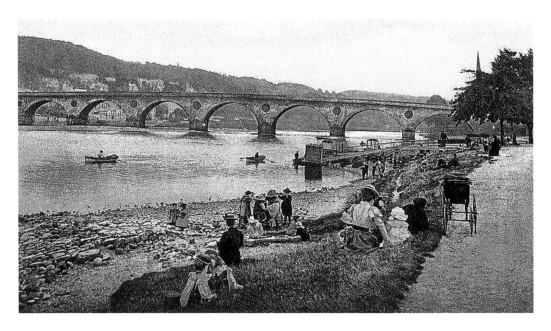

The Boat Station, North Inch

The Boating Station at the North Inch was a popular spot for a paddle in the Tay, messing about in boats or resting with a picnic to take in the magnificent sweep of the Old Bridge. The circular openings between the spans of the bridge were originally intended to allow floodwater to flow through, but were not required and were blocked up.

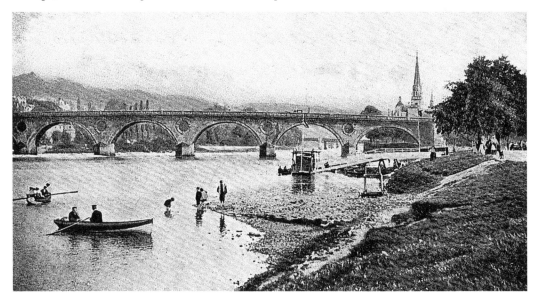

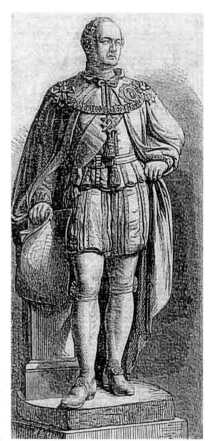

Prince Albert Memorial, Charlotte Street

The 8-ft-high statue of Prince Albert overlooks Charlotte Street at the southern end of the North Inch. Prince Albert is depicted in the robes of the Order of the Thistle and holding a plan of the Crystal Palace, which was erected in Hyde Park, London, for the Great Exhibition of 1851. The memorial was sculpted by William Brodie and was unveiled by Queen Victoria in 1864, three years after Albert's death. The statue is inscribed: 'City of Perth Memorial of His Royal Highness Prince Albert inaugurated by Her Majesty Queen Victoria, Tuesday, 30th August, 1864'.

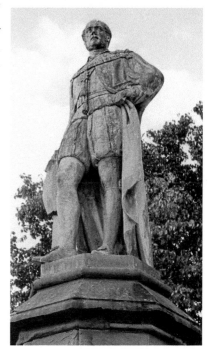

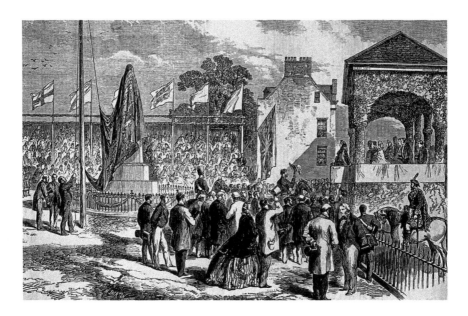

Prince Albert Memorial, Charlotte Street

'The ancient and picturesque city of Perth has seldom worn a livelier aspect than it did yesterday on the occasion of the royal ceremony of inauguration of the Albert memorial statue on the North Inch. A holiday was proclaimed in the town, the streets were dressed in bunting, and the inhabitants of the city turned out in their gayest attire to welcome Her Majesty. People poured into the city from all quarters; and ere evening the extensive hotel and tavern accommodation of the place was tested to its utmost limits. The royal party left the General Station about twenty minutes before ten o' clock. The weather was magnificent, and the sun shone brilliantly as the procession betook its slow passage down the streets set apart for it. The ceremony itself was of the simplest kind, and did not from first to last take more than ten minutes. Her Majesty expressed her high gratification with the splendid statue by Mr Brodie, and remarked upon the striking likeness which it presented of her late husband.' (*Scotsman*, August 31 1864)

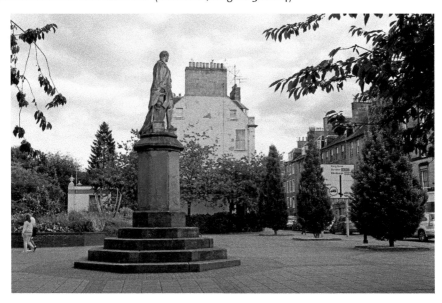

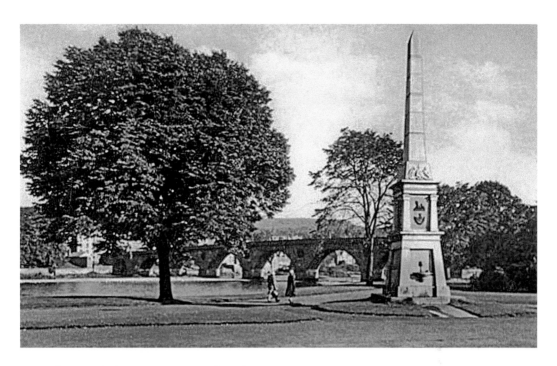

The Lynedoch Monument, North Inch

The Lynedoch Monument was unveiled in December 1896 to commemorate the raising of the 90th Light Regiment of Foot, the Perthshire Volunteers, in 1794. The inscription reads: 'Raised May 1874 by Thomas Graham of Balgowan who was promoted for his services in Italy, Spain and Holland to the rank of General 1809. Made a Knight of the Bath 1812 and created Baron Lynedoch 1814.' Thomas Graham owned a number of estates around Perth. He took up military service at the age of forty-five and rose to a senior role under Wellington.

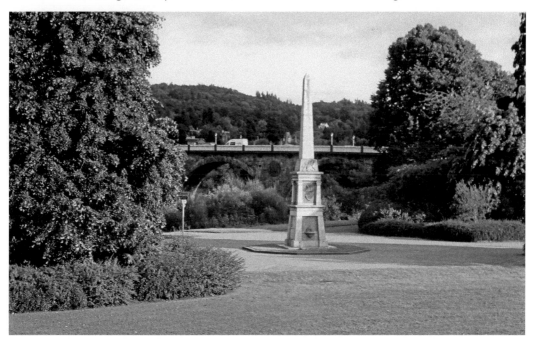

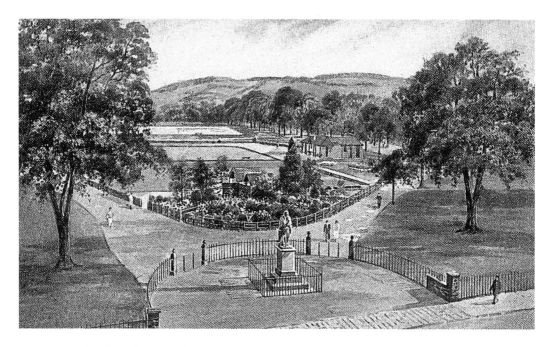

Entrance to South Inch at Marshall Place

Looking along that painted spacious field
Which doth with pleasure profits sweetly yield
The fair South Inch of Perth and banks of Tay.

(Lines on the Monasteries, *Muses Threnodie*)

The South Inch and North Inch define the north and south boundaries of the city centre and, together with the River Tay, contribute to Perth's unique character

The statue of Sir Walter Scott and his deerhound, Maida, at the Marshall Place entrance to the South Inch is by local sculptors the Cochrane brothers, and was first unveiled in 1845 on a site at the foot of the High Street. It was moved to its current site in 1877.

The South Inch was used as an archery ground, a bleach field, for cattle grazing, horse racing and a burial ground for plague victims. The golf course on the South Inch was popular during the eighteenth century, but was abandoned in 1833 when the Royal Perth Golfing Society moved to the North Inch.

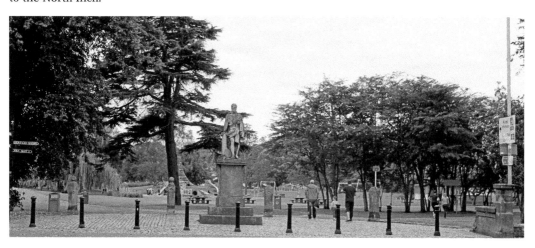

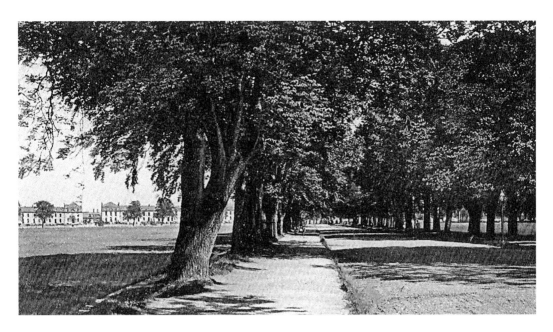

South Inch Avenue

These images show the avenue of elms that line the Edinburgh Road. The road leads directly to the former Perth Water Works, which were designed by Dr Adam Anderson, rector of Perth Academy, and date from 1832. They were built after the loss of the water supply for two weeks in 1827. Water was pumped to the cistern from filter beds at Moncrieffe Island and stored in the cast-iron rotunda for distribution to the town. The Water Works closed in 1965 and were converted into the Fergusson Gallery in 1992.

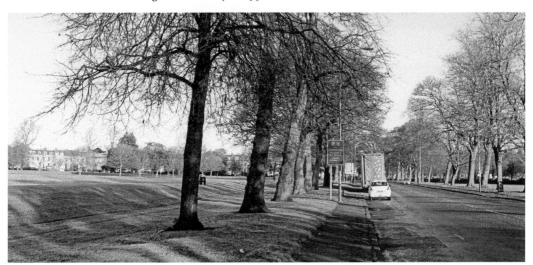

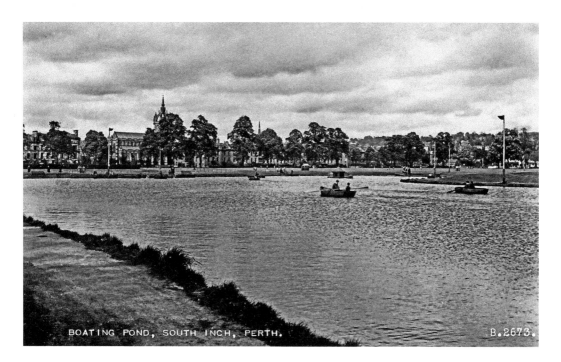

BOATING POND, SOUTH INCH, PERTH. B.2673.

Boating Pond, South Inch

'Believe me, my young friend, there is nothing - absolutely nothing - half so much worth doing as simply messing about in boats.' (The Water Rat from *The Wind in the Willows* by Kenneth Grahame.)

In the 1840s, there were proposals to build a railway station on the South Inch, which provoked outrage among the people of Perth and resulted in a petition being submitted to Parliament against the loss of their cherished green space. The boating pond at the South Inch was recently given a makeover as part of a project to upgrade facilities at the park.

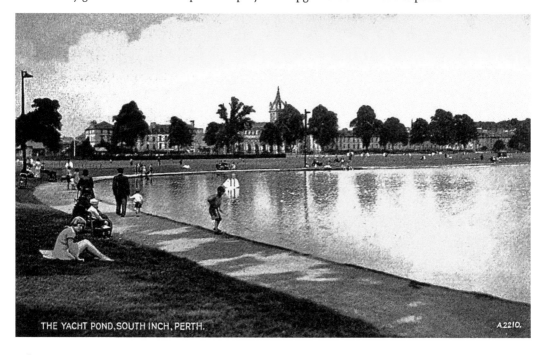

THE YACHT POND, SOUTH INCH, PERTH. A2210.

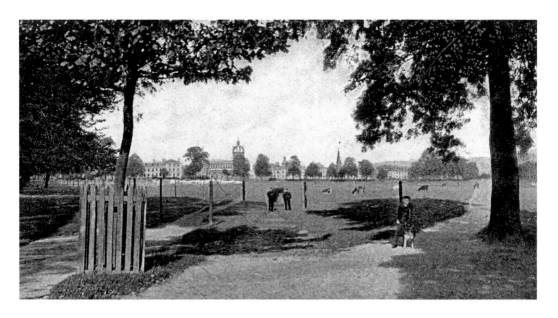

South Inch

Perth surrendered to Oliver Cromwell's Parliamentarians in 1651, and South Inch was the site of Cromwell's citadel, built to subdue the surrounding area and garrison the army.

> Cromwell erected his citadel at Perth, on the east side of the South Inch. This vast building was a square, each side being 266 feet in length. The north wall ran parallel to Greyfriars burying-ground, and extended from the river to the site of Marshall Place. There was a bastion at each corner. The walls of the Greyfriars were demolished, and between 200 and 300 tombstones carried away to be used as building material for the citadel. It is further recorded that no less than 140 houses were pulled down, also the hospital, the Grammar School, the stone pillars and abutments of the bridge, besides kilns and cobbles — all for building material. (*Perth, the Ancient Capital of Scotland*, Samuel Cowan, 1904)

The citadel was dismantled after Cromwell's death and its site is now occupied by the South Inch car park.

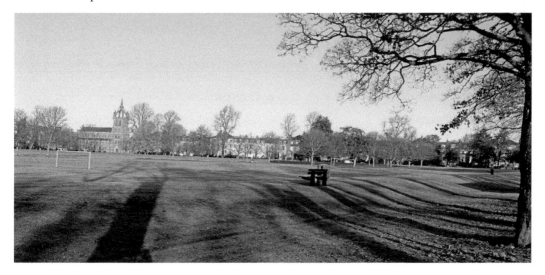

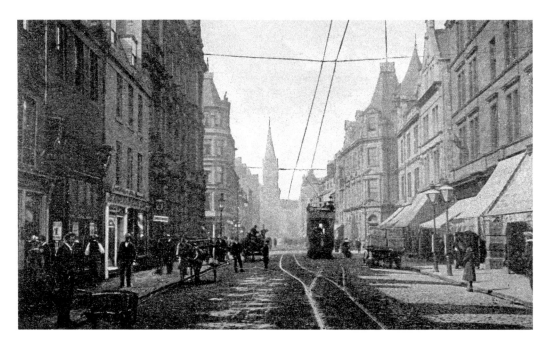

High Street I

Views of the High Street, Perth, looking west, with the tower of St Paul's Church in the background. Perth developed on a plan of two parallel streets, the High Street and South Street, linked by a warren of lanes or vennels leading north and south. The names of these vennels have historic origins and many, such as Cow Vennel and Fleshers Vennel, reflect the trades associated with them in the past.

The original old buildings were redeveloped with tenements, shops and businesses in the late eighteenth and early nineteenth centuries

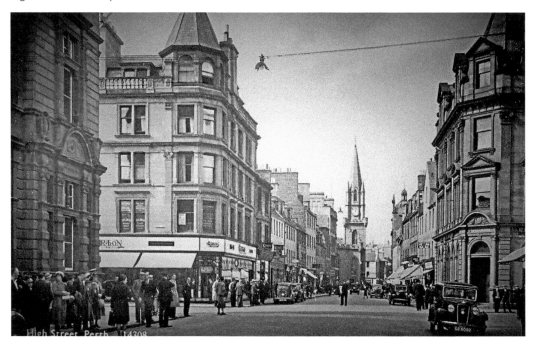

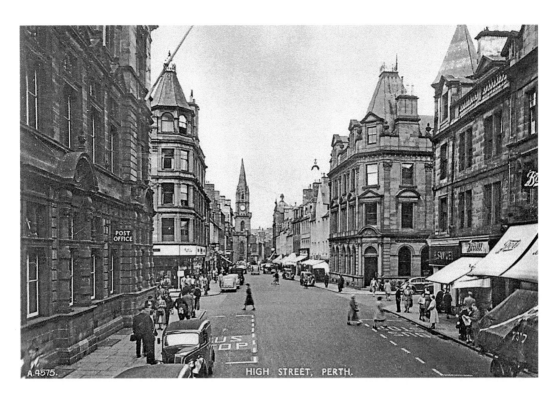

High Street II

These views are looking west on the High Street with Kinnoull Street to the right and Scott Street to the left. The post office building on the left of the older image is the only noteworthy redeveloped building on this stretch of the High Street. The pedestrianisation of the street has made a significant difference to the environment of the High Street.

The canopy over the entrance to Perth Theatre can be seen on the right of the newer image. The theatre opened in 1901.

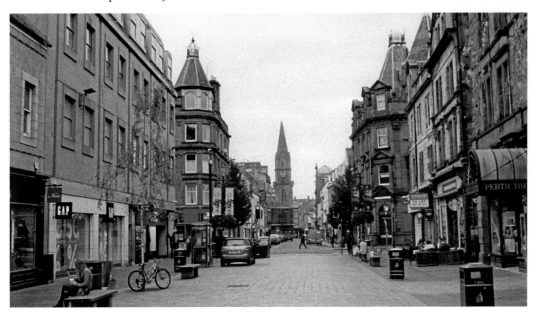

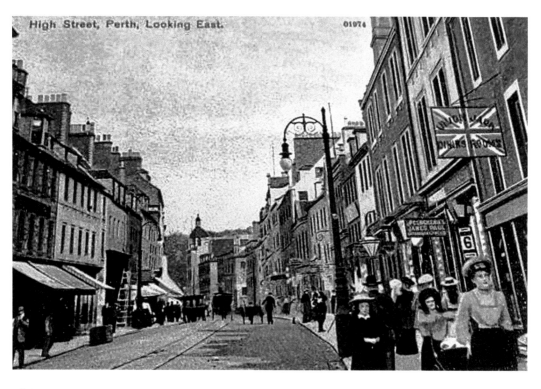

High Street, Perth, Looking East.　01976

High Street III

These views are looking east on the High Street, with the dome of the General Accident Fire and Life Assurance Corporation in the background. King Edward Street, which opened in 1902, is missing from the older image.

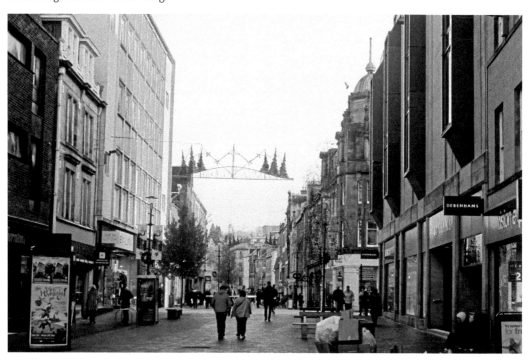

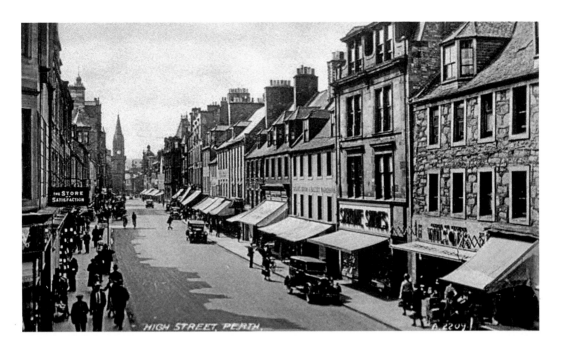

High Street IV

There has been considerable redevelopment between the dates of these two images of the High Street. The Store of Satisfaction on the corner with King Edward Street has been replaced by a Debenham's shop.

The statue in the right foreground of the newer image is the *Soutar Ring* by David Annand. Erected in 1992, the ring is inscribed with the first verse of the poem 'Nae Day Sae Dark' by local poet William Soutar (1898–1943):

> Nae day sae dark; nae wud sae bare
> Nae grund sae stour wi' stane
> But licht comes through; a sang is there
> A glint o' grass is green.

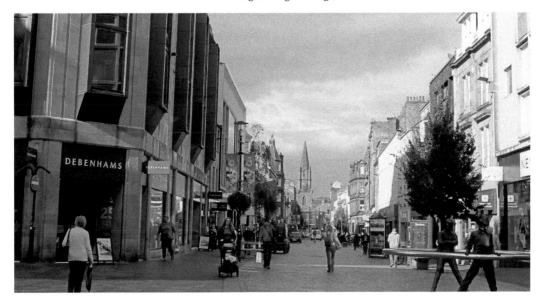

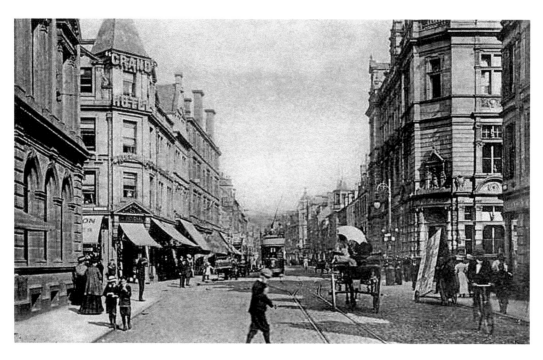

High Street V

In the Perth Street Directory of 1903, the Grand Hotel was advertised as the most central hotel in Perth. The hotel offered dinners for 2s and provided 'every comfort for cyclists'.

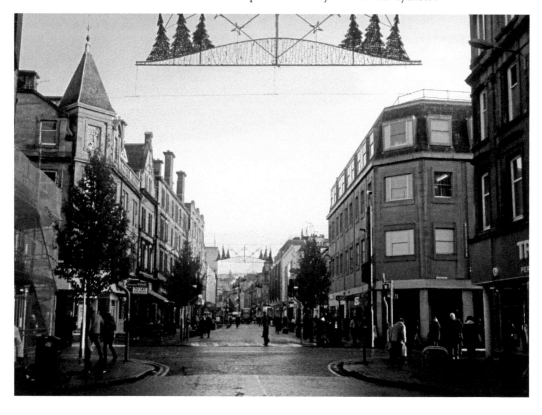

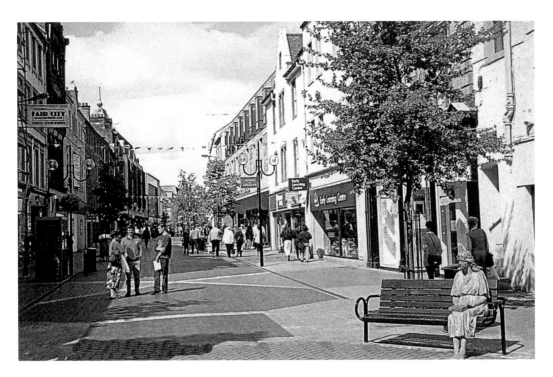

The Fair Maid, High Street

The charming statue of the Fair Maid of Perth sitting reading a book on a bench on the High Street is by Graham Ibbeson and was erected in 1995. It is hard to resist taking the opportunity for a photo sitting beside her. The Fair Maid has changed sides of the High Street since she originally took a seat on her bench.

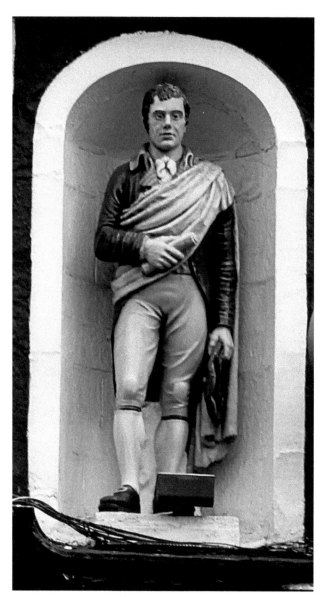

Burns in Perth
A bronze plaque at No. 186 High Street commemorates the visit by Robert Burns to Perth in September 1787. The inscription reads: 'Robert Burns visited Perth 14th-15th Sept 1787 and stayed at Croom's Tavern, High Street.' Burns noted in his journal on 14 September 1787 that he 'came through the rich harvests and fine hedge-rows of the Carse of Gowrie, along the romantic margin of the Grampian hills to Perth'. There is also a rather fine statue of Burns in a recess above the Robert Burns Bar in County Place.

ROBERT BURNS VISITED PERTH
14TH–15TH SEPT 1787 AND
STAYED AT CROOM'S TAVERN
HIGH STREET.
BUILDING IN CLOSE — LEFT-HAND SIDE.

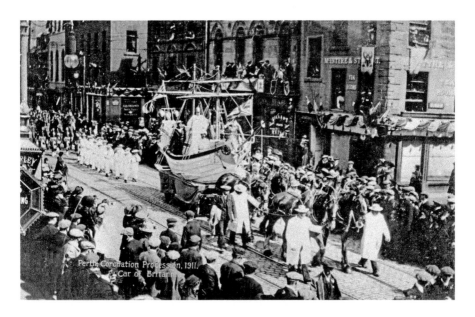

Coronation Parade 1911

Perth celebrated the Coronation of George V on 22 June 1911 in a grand manner. The image of the coronation procession on the High Street shows Britannia in her boat.

> The celebrations in Perth were carried out on an extensive scale. The afternoon was chiefly occupied with a procession and pageant. The pageant was representative of the British Empire, and proved a magnificent display. There were a dozen cars, each emblematic of different parts of the Empire, and attended by escorts in native costumes. In all about 800 ladies and gentlemen took part. They marched through the principal streets to the North Inch, and on arrival there Britannia in a ship took up position in the centre of an arena which had been formed. The evening was devoted to music and dancing, and at 10.30 the city was illuminated and bonfires were lit.
>
> (*Scotsman*, 23 June 1911).

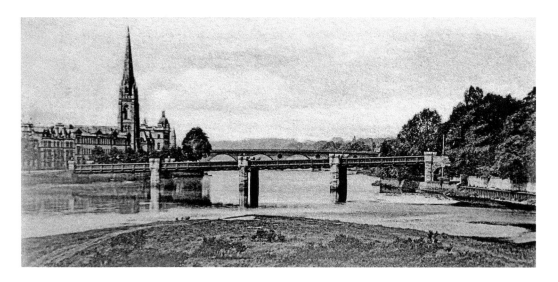

Victoria Bridge

As road traffic built up at the end of the nineteenth century, it was clear that a second crossing of the Tay was required to relieve pressure on the Old Bridge. The Victoria Bridge was opened by Lady Pullar in 1900, linking South Street to the Dundee Road. It was a steel-truss bridge spanning between concrete piers. Construction was delayed by protracted negotiations with the owner of a villa, Rodney Lodge, which was in the direct line of the new bridge on the east bank. The house was eventually compulsory purchased, but the owner left the gables standing each side of the new bridge as a protest.

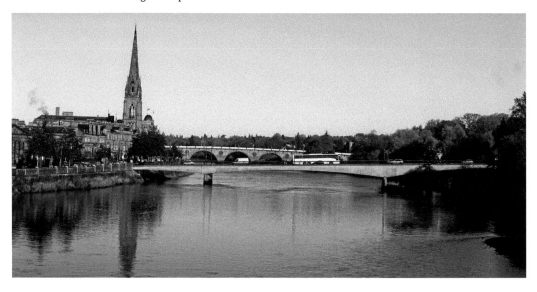

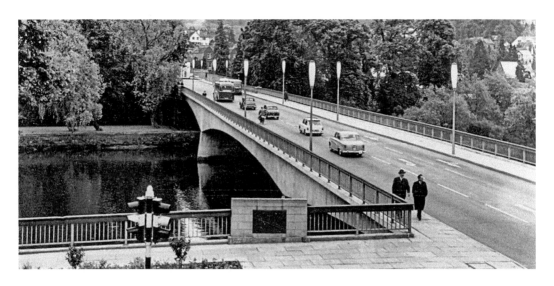

Queen's Bridge

The Queen's Bridge was opened by the queen on 10 October 1960 as a replacement for the Victoria Bridge. The date was significant as the 750th anniversary of the granting of the Perth's royal charter in 1210. It is a light and graceful structure of shallow arches. The old bridge was ingeniously jacked-up and the new prestressed-concrete bridge slotted in beneath it to allow traffic to keep crossing the Tay.

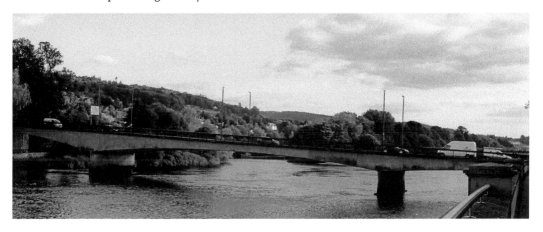

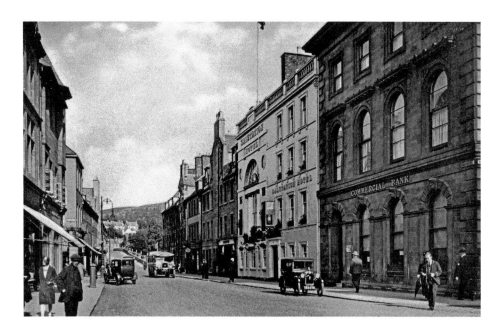

South Street

These views are looking east on South Street with St John Street to the left, opposite the Salutation Hotel. Little has changed in the overall form of the buildings. The Salutation Hotel is an enduring feature of the street. The Classical Italianate style of the Commercial Bank, on the corner with Princes Street, is based on a Florentine Renaissance palazzo and dates from 1858. It is particularly finely detailed with round-arched windows to the ground floor with carved masques to the keystones. It is now a restaurant.

South Street was once the site of Perth's weekly shoe market and was known as the Shoe Gait. It was originally terminated at its east end by Gowrie House. Direct access to the river was made on the demolition of the house in the early nineteenth century, and South Street became a busy through route when the Victoria Bridge was opened in 1900.

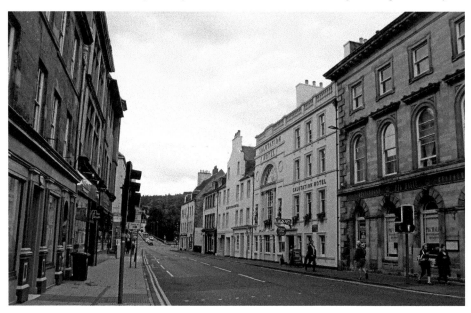

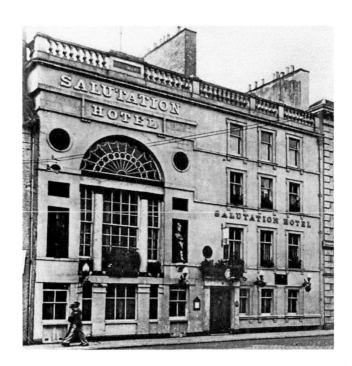

Salutation Hotel, Nos 30–36 South Street

The Salutation Hotel lays claim to being the longest-established hotel in Scotland. It was a coaching inn between 1699 and 1745, and was the main resting point on the coach roads from Edinburgh and Glasgow to Aberdeen and Inverness.

The west side of the building dates from the eighteenth century with an early nineteenth-century neoclassical extension to the east, which was added by Sir Robert Reid, the king's architect in Scotland, and incorporates the large arched window.

The name, the Salutation, is said to derive from John Burt, an early landlord, having shaken hands with Prince Charlie, who stayed at the hotel in 1745.

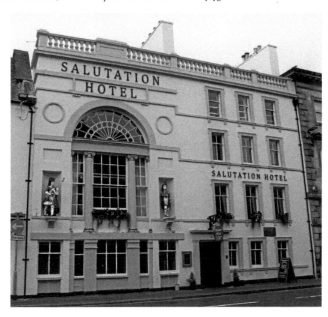

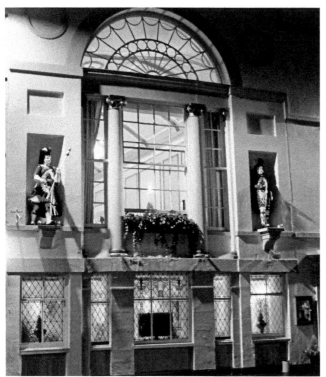

Salutation Hotel

We reached Perth before nine, very tired, and put up at an admirably kept hotel – the Salutation, very large, very reasonable, a Bible in every room and the civil landlord quite tipsy. After an excellent night and a comfortable breakfast we took leave.

(*The Highland Lady in Ireland*, Elizabeth Grant of Rothiemurchus, 1898).

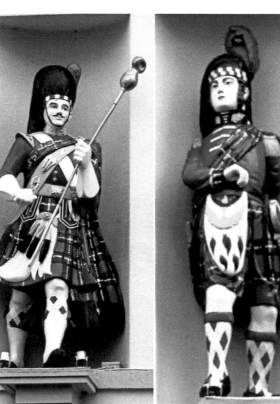

The massive Venetian window and imposing arched fanlight fronting the Adam-style restaurant room at the Salutation Hotel provide a striking focal point at the end of St John Street. The distinctive painted figures on the frontage depict an officer and a pipe major of the Black Watch.

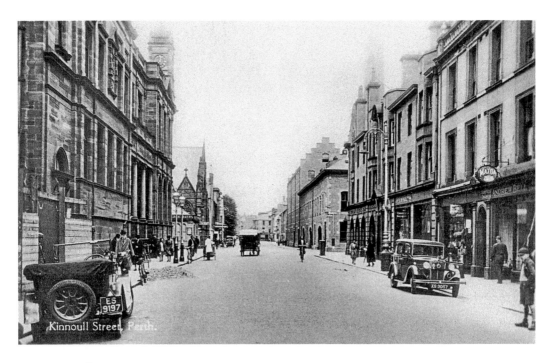

Kinnoull Street

Looking north on Kinnoull Street, which was laid out in 1823. The older image shows the former Sandeman Library on the left side of the street and the enormous Pullar's North British Dyeworks in the right background. The Congregational Church is to the right of the former Sandeman Library.

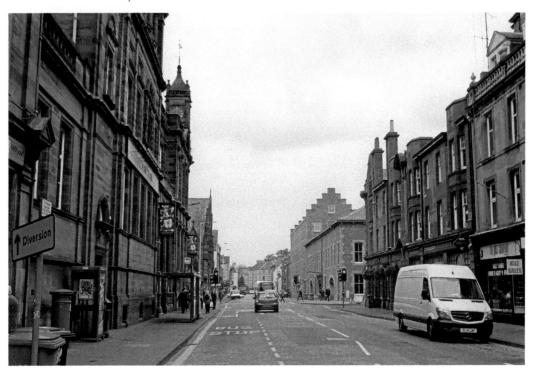

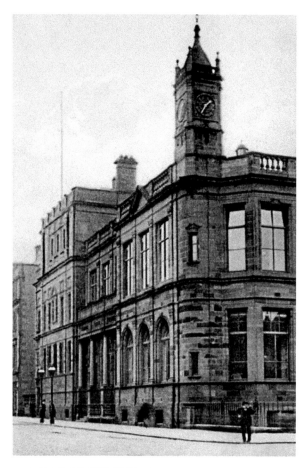

Sandeman Library, Kinnoull Street

Perth Town Council did not have the funds to provide a free public library under the terms of the Free Libraries Act of 1882. However, a benefactor came forward in the form of Professor Archibald Sandeman of Queen's College, Cambridge. Professor Sandeman came from a local family and bequeathed £30,000 to establish a free public library in Perth.

The opening ceremony of the library in October 1898 was performed by the Earl of Roseberry in the presence of local dignitaries. Before the opening, there had been a parade through the decorated streets of Perth, and, after the opening, Roseberry was given the Freedom of the City.

The Sandeman Library closed in 1994 when the AK Bell Library opened in the refurbished former infirmary building. The building with its distinctive corner clock tower is now occupied by the Sandeman public house.

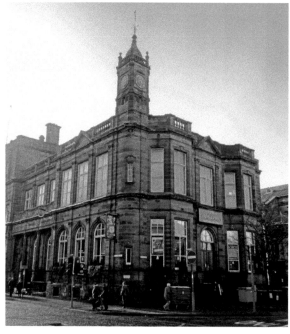

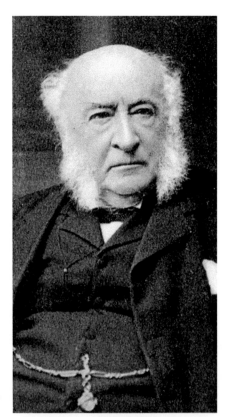

J. Pullar & Sons of Perth

John Pullar announced the opening of his gingham dyeing business in Burt's Close, Perth, with an advert in the *Perth Courier* in 1824. Robert Pullar (1828–1912), James' son, was apprenticed at the age of thirteen in the family business and became a partner in 1848. Robert expanded the company with agents in the surrounding towns and introduced a postal service, which covered the whole country. In 1852, Pullars was awarded a royal warrant – Dyer to Her Majesty the Queen. Robert Pullar was knighted in 1895 for services to business and was awarded the Freedom of the City of Perth in 1911. He was also the Member of Parliament for Perth from 1907 to 1910.

The plaque at the entrance to the former Pullar Building shows Robert Pullar and the Pullar factory in 1848.

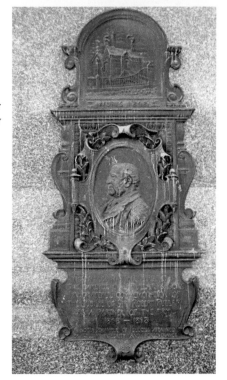

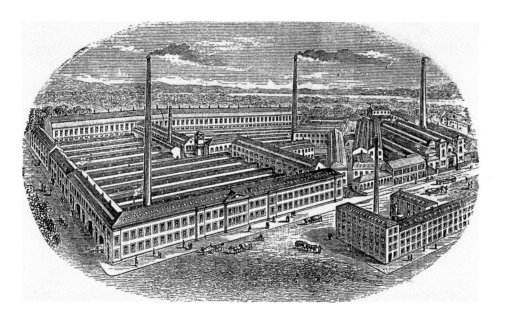

Pullar's Building, Kinnoull Street

In the late nineteenth century Pullars was the largest dye works in Scotland, employing over 2,600 workers. Pullars was the first company to provide a dry-cleaning service in Britain and pioneered the use of synthetic dyes. The company operated the largest dry-cleaning machine in the world, capable of cleaning carpets measuring 100 square yards.

Falling orders during the First World War resulted in short working hours, reduced wages and industrial unrest. The company was taken over by Eastman & Sons, although continuing to trade under the Pullars name. The building was converted for office use in 2000.

P. & P. Campbell of Perth

The Perth firm of dyers P. & P. Campbell specialised in colourful adverts. The dye works of P. & P. Campbell was founded by Archibald and Peter Campbell in Methven Street in 1814, some ten years before Pullars. By the 1880s, the business was operating from custom-built premises in St Catherine's Road. Following a devastating fire in 1919, Campbells was taken over by Pullars.

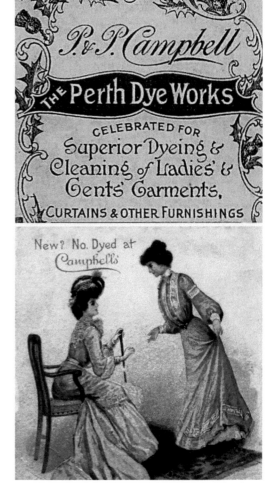

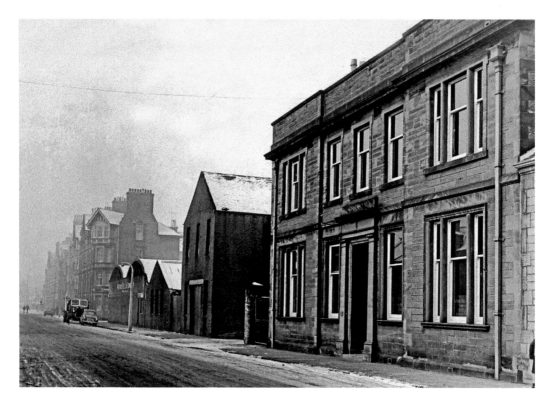

Bells, Victoria Street

The headquarters of Arthur Bell & Sons Ltd whisky distillers on Victoria Street are shown in the older image. Arthur Bell (1825–1900) first started blending whisky in Perth in 1951. It was one of his sons, Arthur Kinmond (1868–1942), known as 'A K', who is best remembered in Perth for his business acumen and philanthropy. There was some controversy in 1998 when United Distillers, Bell's parent company at the time, proposed closing the Perth headquarters, with pubs placing an embargo on the sale of Bell's whisky. The closure went through and the building was redeveloped as a shopping centre.

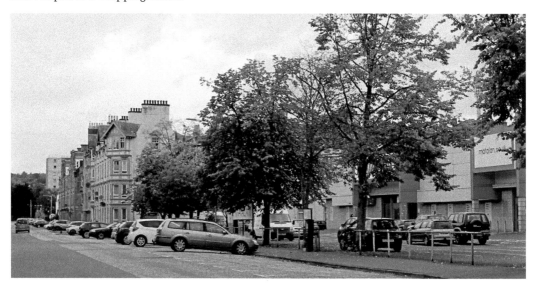

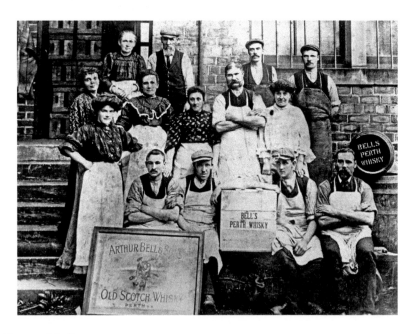

Arthur Kinmond Bell

Contrasting images of workers and managers at Bell's in the early part of the twentieth century. The workers display a framed advert with the famous Bell's curler logo. The managers are posed outside the entrance to the Victoria Street headquarters, with AK Bell, the managing director, at the centre of the group. Three families made Perth the whisky capital of Scotland in the nineteenth century: Gloag (the name behind the Famous Grouse), Dewar and Bell. However, it was AK Bell that had the biggest impact on the life of Perth.

AK Bell used part of his fortune for the benefit of his native city. Among his many philanthropic activities was the building of the Gannochy housing estate to provide affordable housing and the formation of the Gannochy charitable trust in 1937. He also contributed to improvements to the town's water supply. He was presented with the Freedom of Perth on 18 March 1938 and is commemorated in the naming of the AK Bell Library.

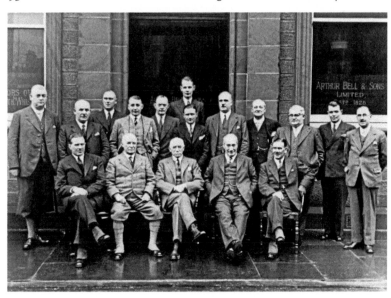

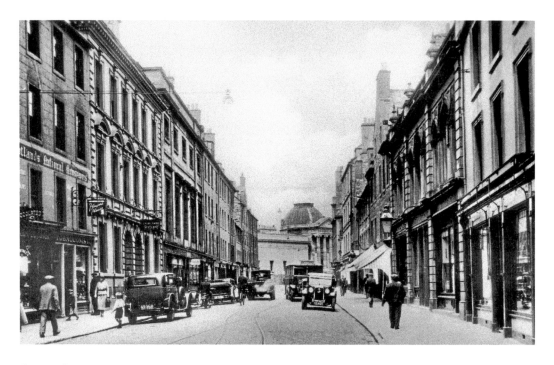

George Street

George Street was opened as a planned street in 1771 to provide access to the new bridge. It is named after George III. The curved line of the road emphasises the dome of the Perth Museum and Art Gallery, which can be seen at the far end of the street. The gallery dates from 1824, with an art deco extension of 1931, and commemorates Perth's provost Thomas Marshall. The building with the ornate façade on the left of the street was the headquarters of the Perth Bank, with the former Exchange Coffee Room next door.

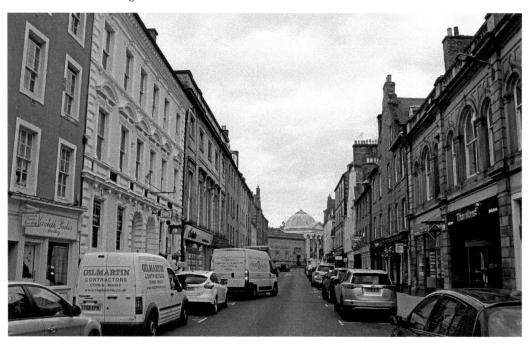

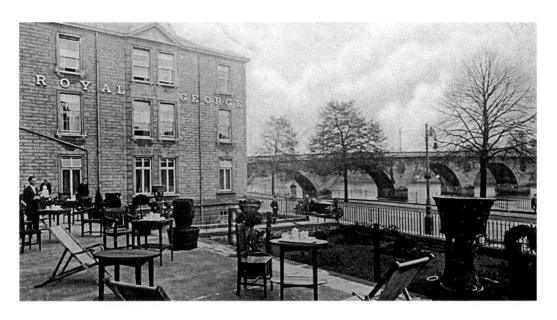

Views from the Royal George Hotel

The Royal George Hotel opened in 1773. It originally served as a coaching inn, with stabling for the mail coaches that stopped at Perth's first post office, over the road from the George. It also provided accommodation and refreshment for travellers. The hotel was considerably expanded by its enterprising landlord William Steele, who took over the premises in the 1900s.

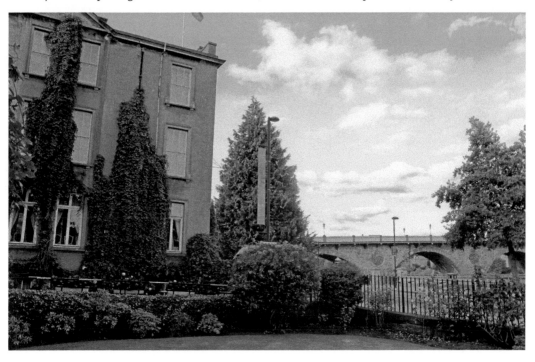

Queen Victoria at the George Hotel

Queen Victoria arrived for a surprise overnight stay at the George Hotel on 29 September 1848, after it was considered to be unsafe, due to bad weather, for her to travel by ship from Aberdeen on her way from Balmoral to London. She travelled by train from Montrose and was accompanied by Prince Albert, the Prince of Wales, Prince Alfred and the Princess Royal. The hotel was only given a few hours' notice of the arrival of the royal party and had to make hasty arrangements for the visit. The queen had never stayed in a hotel before and was so impressed by the welcome she received that she granted the hotel a royal warrant.

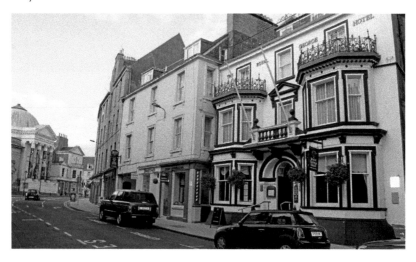

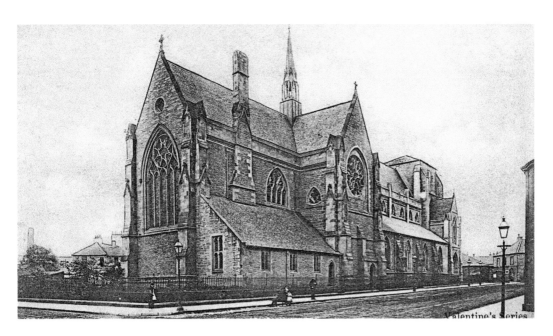

St Ninian's Cathedral, Atholl Street and North Methven Street

St Ninian's Cathedral occupies a prominent location on the corner of Atholl Street and North Methven Street. It was built in phases and first opened for worship in 1850. It stands on the site of an older Dominican monastery. The design was by the renowned ecclesiastical architect William Butterfield (1814–1900). It was the first cathedral built in Britain after the Reformation.

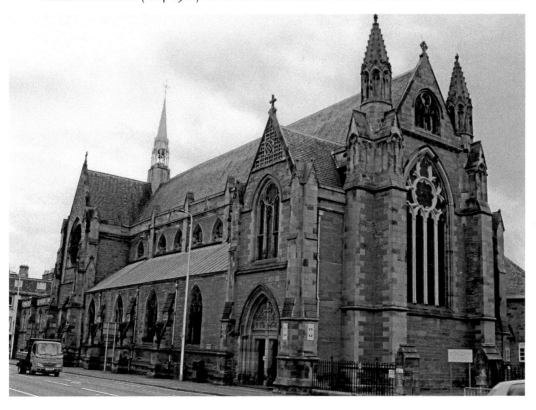

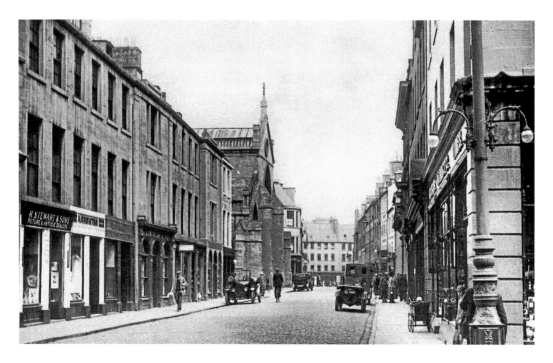

St John Street

These views are looking north on St John Street with St John's Church on the left of the images. St John Street was developed in the early nineteenth century on the line of the old Ritten Row to improve access to the new bridge. It is lined by elegant terraces with ground-floor shops. The ornate red-sandstone building on the right of the images was the original headquarters of the Central Bank. The McEwens of Perth department store, which was first established in St John Street in 1868, closed in May 2016.

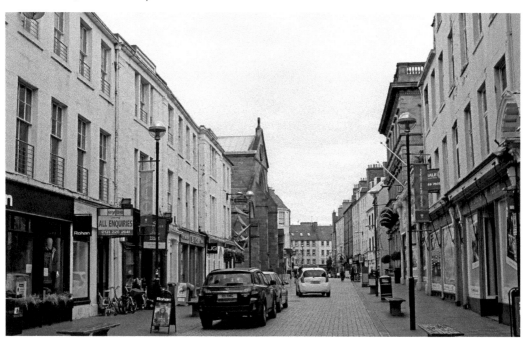

Perth Mercat Cross

Mercat crosses were a symbol of a town's right to hold a market – an important privilege. It marked the spot where trade was carried out and public proclamations were made. Perth's early mercat cross stood on the High Street opposite Skinnergate; the site is marked by an octagon of stone in the kerb at the junction of the High Street with Skinnergate. It was around 12 feet high with a balcony on the top, from which proclamations were read. The cross was pulled down in 1651 by Cromwell in order to get stones for his citadel on South Inch. Another cross was erected in 1669, but it proved an obstruction to traffic and was removed in 1765. The present cross in St John's Square was erected in 1913 as a memorial to Edward VII.

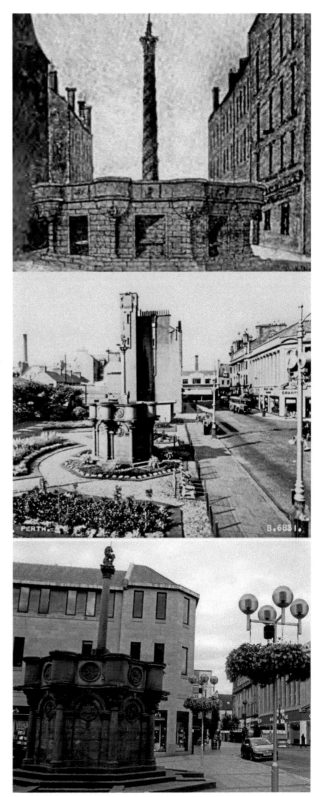

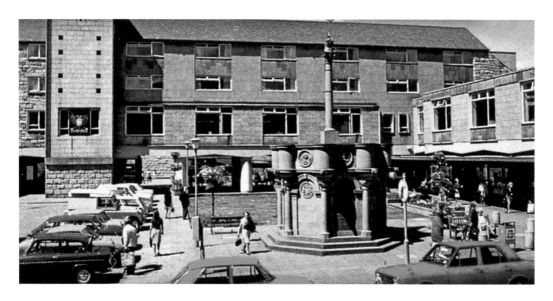

St John's Square

The St Johns' Square mixed-use development of housing, shops and offices was the result of redevelopment in the 1960s. It was relatively short-lived and was itself redeveloped as the Saint John's Centre in the 1990s. The mercat cross has endured through all the changes in this area.

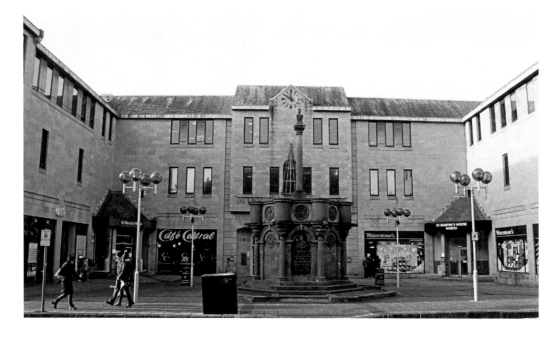

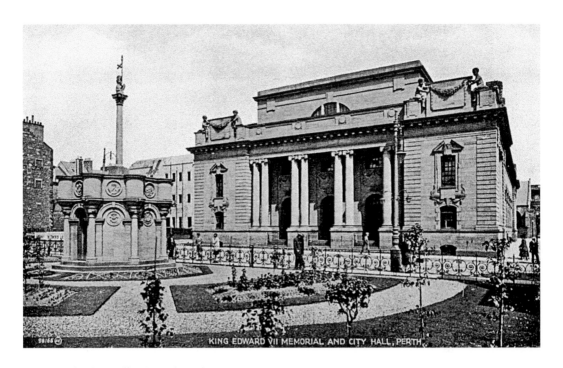

Perth City Hall, King Edward Street

King Edward Street was completed in 1902 as a new street linking the High Street and South Street. The new City Hall was opened on 29 April 1911. Its imposing baroque frontage with giant Ionic columns dominates the east side of the street. It is well known as the venue for Conservative Party conferences. The hall has been disused since Perth's new concert hall opened in 2005 and, at the time of writing, the building's future is uncertain.

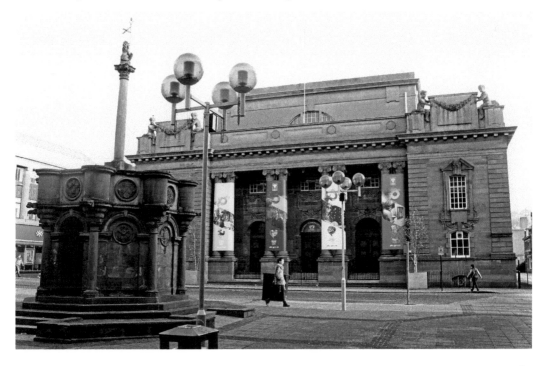

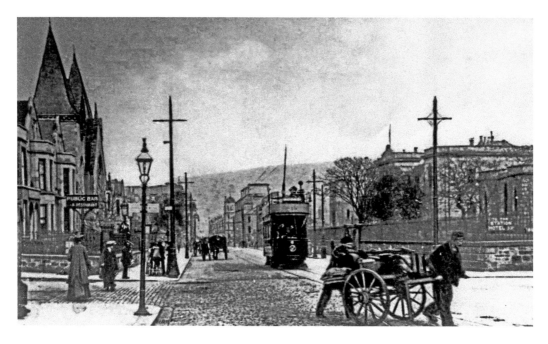

York Place

These views are looking east on York Place. It's a busy scene in the older image with a cart crossing the road just before a tram passes. The public bar sign for the Waverley Hotel is prominent in the left foreground and a sign on the railings at the corner with Caledonia Road provides directions to the Station Hotel. Trinity Church, which dates to 1860, with its twin towers capped by tall pyramidal roofs, stands next to the Waverley Hotel.

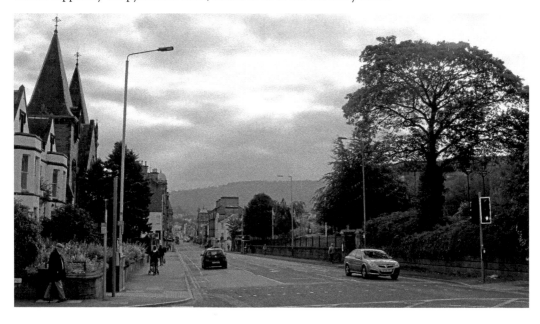

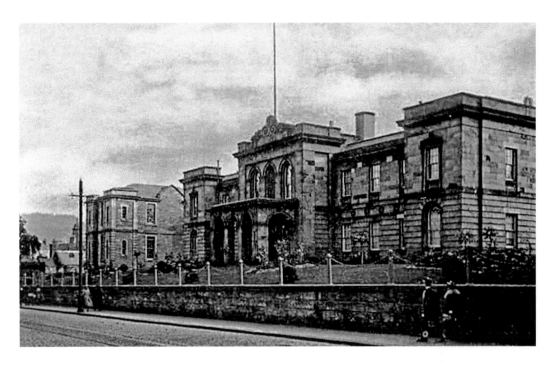

Infirmary/Library, York Place

The building was designed by William Macdonald Mackenzie (1797–1856), Perth's city architect for thirty years, and opened as the County and City Infirmary in 1837. It was the main hospital for the district until the Perth Royal opened in 1914. During the First World War it was a Red Cross Hospital, tending to war wounded. It was then used as council offices, until it was converted into the AK Bell Library in 1994. The original infirmary building survives at the heart of the new library.

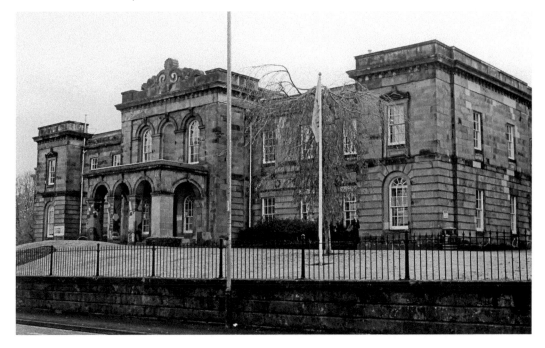

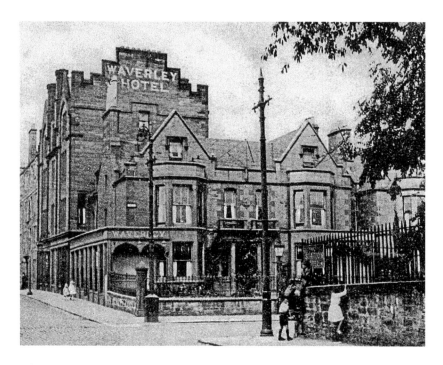

Waverley Hotel, York Place

The Waverley Hotel was established in around 1900 and, for over a hundred years, was a popular Perth hostelry and provided accommodation for travellers using the nearby station. When the building closed as a hotel, it was used as a hostel, which also closed in August 2011. The building was badly damaged by a major fire on 17 November 2015. At the time of writing, the building stands derelict with a large hole in the roof and there is an ongoing debate about its future.

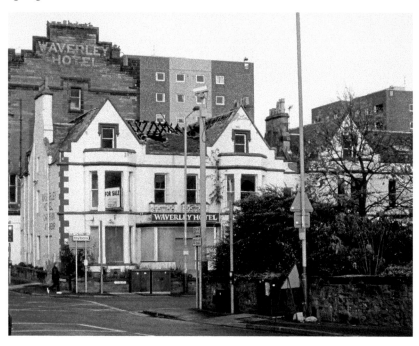

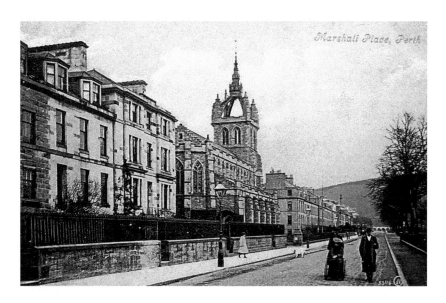

Marshall Place I

'It is impossible to turn the eye to any quarter of Perth or its environs without some remarkable remembrance of Provost Marshall coming into view. He had a particular pleasure in planning and a particular energy in carrying out whatever appealed to him calculated to adorn, improve or in any way beneficial to his native town.' (*Scots Magazine*, 1808).

Marshall Place takes its name form Provost Thomas Hay Marshall. Marshall (1768–1808) was a Baillie at age twenty-two and twice provost. Marshall was the inspiration behind many improvements to Perth including the development of numerous new streets of elegant Georgian architecture.

The street of smart Georgian houses comprises two symmetrical palace-fronted blocks that overlook the South Inch. They were designed by the eminent architect Robert Reid. They were built from 1806 and were intended to be the first part of a grand scheme to create a southern new town of Georgian terraces. However, they were not completed until 1833 due to legal and financial issues.

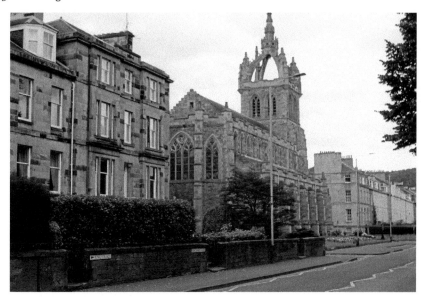

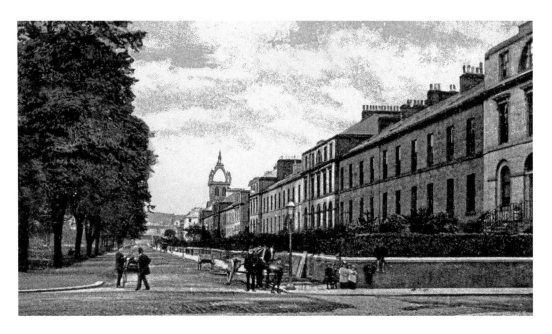

Marshall Place II

St Leonards-in-the-Fields Free Church, with its distinctive crown spire, dates from 1885 and forms an impressive landmark on Marshall Place, overlooking the South Inch. It was built as St Leonard's Free Church and was designed by the London-based architect John James Stevenson (1831–1908). There were some early construction difficulties as part of the cities lade lay underneath the site.

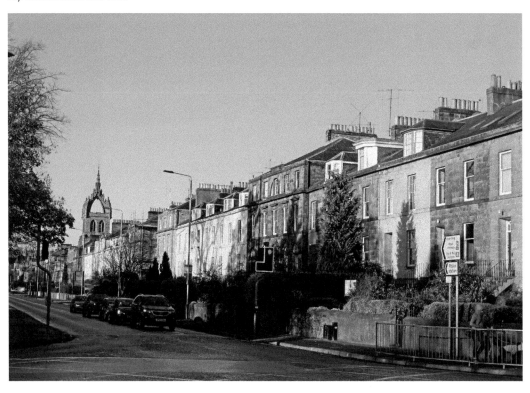

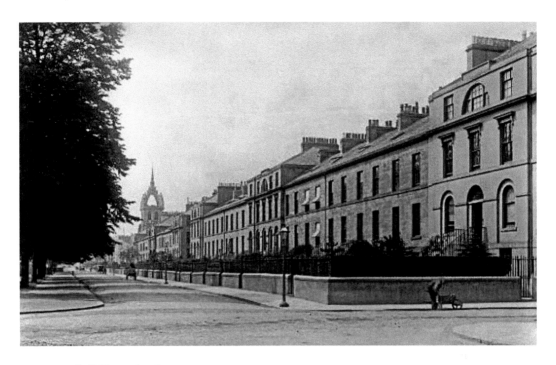

Marshall Place Floods

The fast-flowing waters of the Tay have been the source of a number of extreme floods throughout the history of Perth, with thirty-four events recorded between the years 1210–1993. The first recorded flood was in 1210 and drowned many, including the king's son. In 1621 Perth Bridge was destroyed and the highest flood level ever recorded was in 1814. The image of a flooded Marshall Place is from August 1910. Flood defence works with embankments, walls, floodgates and pumping stations were completed in 2001 at a cost £25 million and now protect the city.

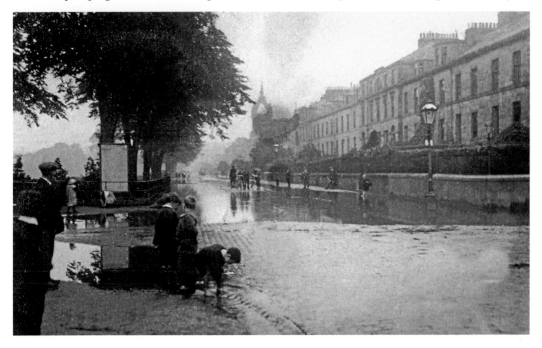

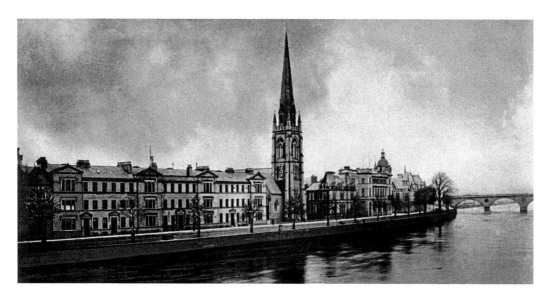

Tay Street I

The Watergate was old Perth's most impressive street, lined by fine houses with long narrow garden plots stretching down to the Tay. It rapidly lost its status when Tay Street, the new grand boulevard along the bank of the river, was opened in the mid-1870s. The clutter of medieval backlands was removed and the city presented an imposing new frontage to the river.

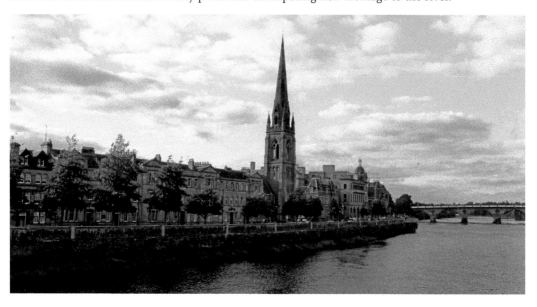

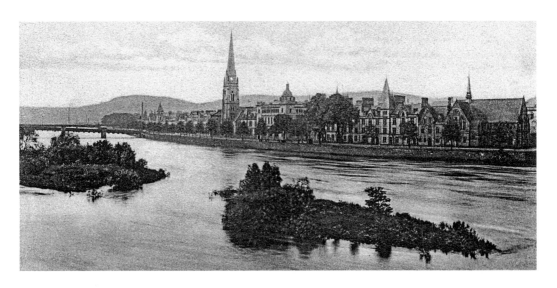

Tay Street II

These views of Tay Street, which are separated by over 100 years, are little-changed. St Matthew's Church, with its 212-ft-high spire dominates the view. The church opened in 1871 as the Free West Church. The red-sandstone building to the right of the images is the former Middle Church dating from 1887, with the former Council Chambers adjoining. On the opposite side of the High Street, the building with the corner dome was the former offices, dating from 1899, of the General Accident Fire and Life Assurance Corporation. General Accident moved out of this building in 1983 and it was converted into the council headquarters. A plaque on the wall at No. 44 Tay Street commemorates the first offices of General Accident, which was founded in 1885 by a group of local farmers and developed rapidly into an insurance giant. The embankment wall was replaced in the course of flood defence work in 1999.

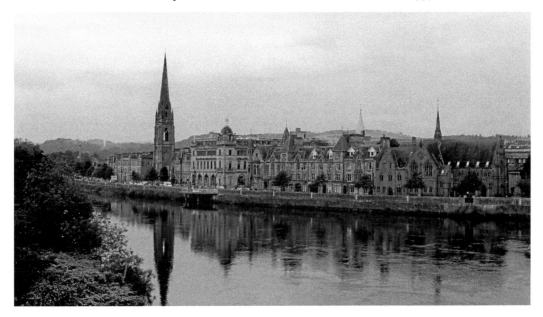

73

Post Office/General Accident, Tay Street/High Street
Perth's elegant-looking old post office at the east end of the High Street was opened in 1860 and removed in 1898 for the redevelopment of the site as the General Accident headquarters. This was also the original site of the statue of Sir Walter Scott, which is now at the entrance to South Inch on Marshall Place.

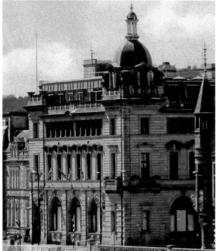

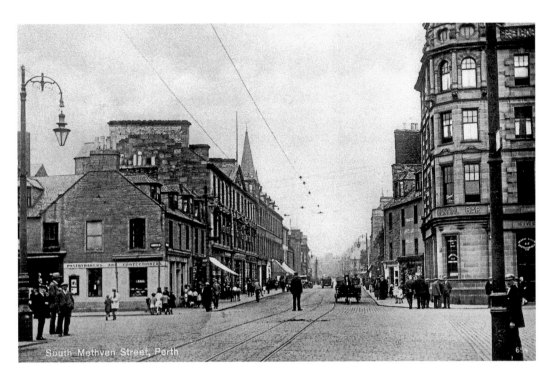

South Methven Street

Views looking along South Methven Street with County Place on the left and South Street on the right. Both of these images predate 1929, when Perth's electric trams were retired. The area was the site of the South Street Port, a gate in the town wall.

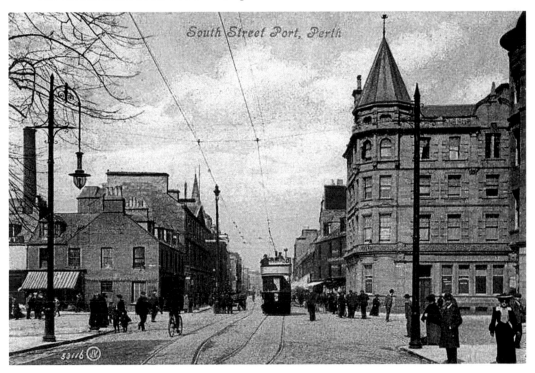

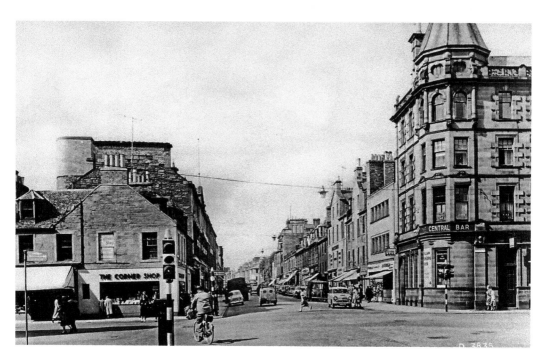

South Methven Street

The prominent building with the octagonal corner spire on the corner with South Street dates from 1901. The original design incorporated the ground-floor pub, which was the Central Bar for decades and is now the Dickens pub.

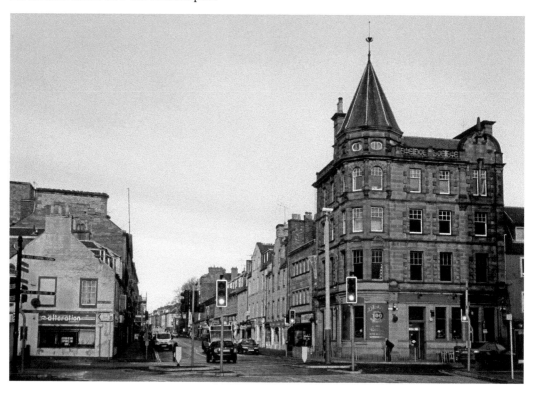

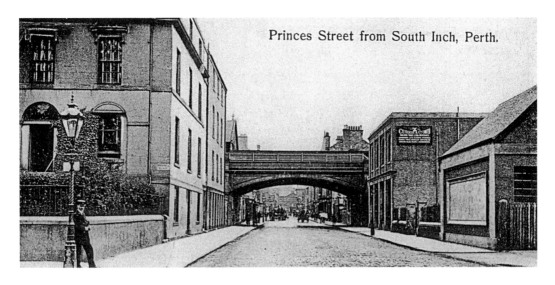

Princes Street from South Inch, Perth.

Princes Street

These views are looking north along Princes Street from Marshall Place. Princes Street was developed in the late eighteenth century to link the Edinburgh Road with the new bridge. Princes Street railway station opened on 24 May 1847 on the Perth–Dundee mainline. It closed to regular passenger traffic on 28 February 1966. The railway line passes behind Marshall Place and is carried over cross streets by a series of bridges.

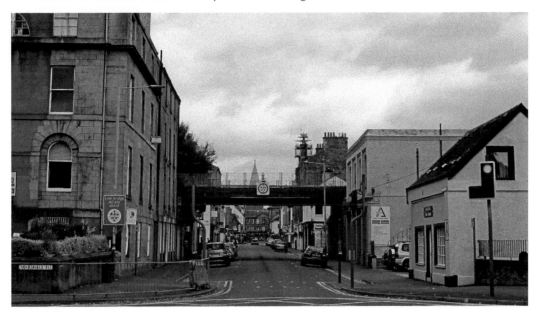

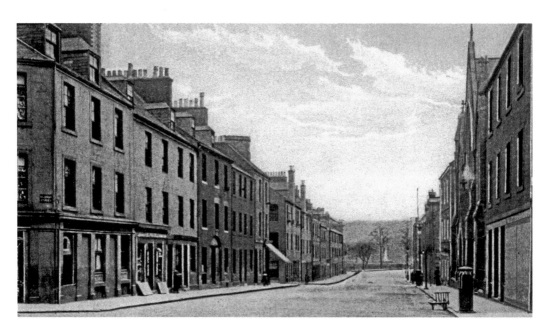

Atholl Street

Atholl Street was the main street in the northern extension to Perth in the late eighteenth and early nineteenth centuries. It is now a busy through route linking directly to the Perth Bridge.

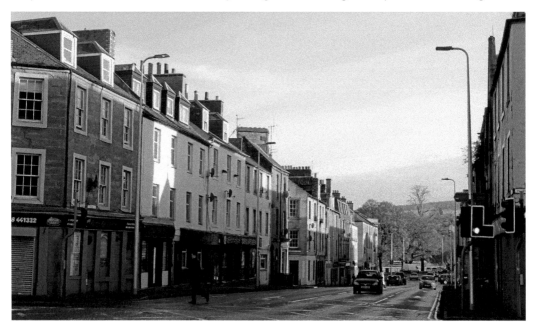

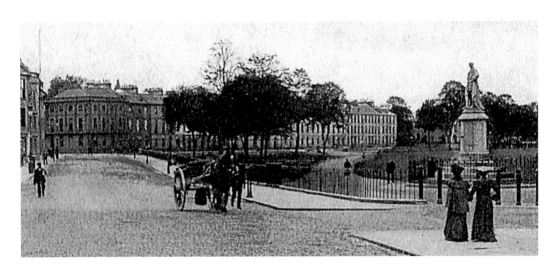

Rose Terrace

Rose Terrace was one of the most elegant terraces in the Thomas Hay Marshall-inspired development of Perth towards the end of the eighteenth century. It forms an impressive edge to the North Inch. It was named for Thomas Hay Marshall's wife, with Marshall's own house on the corner with Atholl Street. Marshall's marriage to Rose Anderson failed due to Rose's affair with the Earl of Elgin. Marshall also suffered business difficulties and died in debt, aged forty, in 1808.

The Old Academy opened in 1807 and forms the centrepiece of the terrace. The sculpture of Britannia and the clock on the parapet were added in 1886. The building ceased to function as a school when the academy moved to new premises in Viewlands Terrace in 1932.

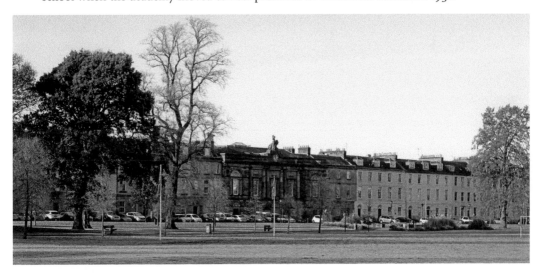

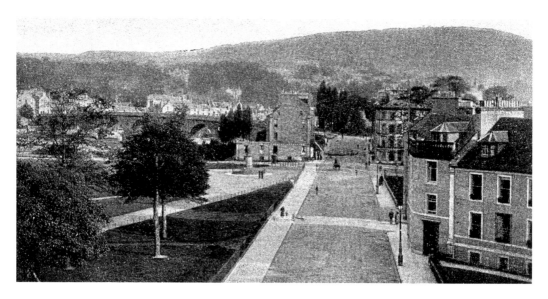

Charlotte Street

These views show Charlotte Street, with Atholl Terrace and Blackfriars Street to the right and the North Inch to the left. Charlotte Street was laid out in 1783 with ordered elegant buildings.

The plaque on the wall at the corner of Charlotte Street and Atholl Terrace in the newer image marks the location of the Blackfriars Monastery. It also commemorates the Battle of the North Inch and the murder of James I at the monastery in 1437.

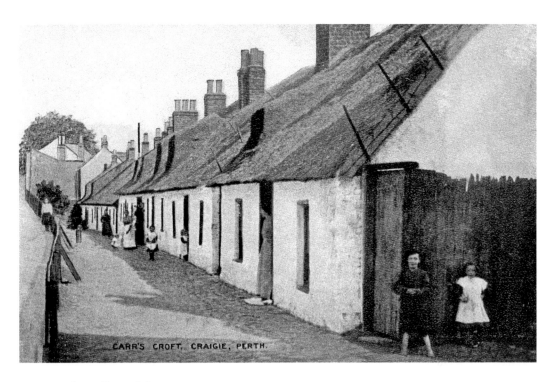

CARR'S CROFT, CRAIGIE, PERTH.

Carr's Croft, Craigie

The older image dates from 1904 and shows a row of thatched cottages, which originally stood on the east side of Priory Place. The site is now a plumber's yard and one of the original cottages just survives – in a derelict condition. It sits lower than in the older image, as the level of Priory Place was raised to allow traffic to cross the St Leonard's Bridge.

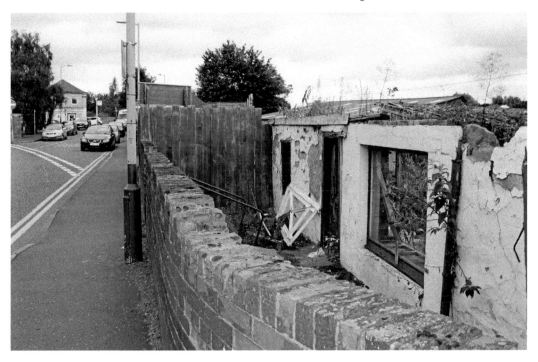

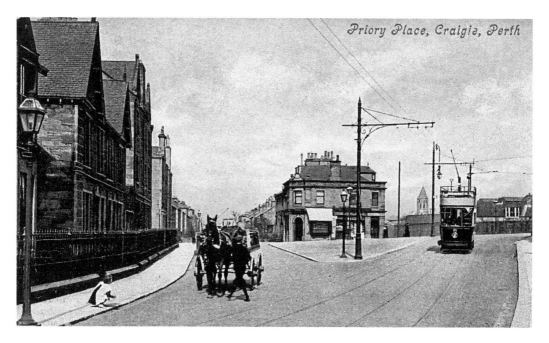

Priory Place, Craigie, Perth

Priory Place

The older image from around 1906 shows tram No. 11 on Priory Place. The horse and cart have been stopped to allow the tram to pass and a little girl is crouched on the pavement.

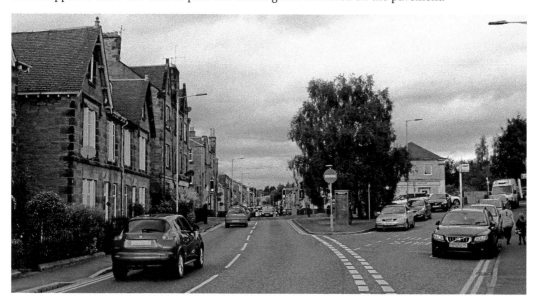

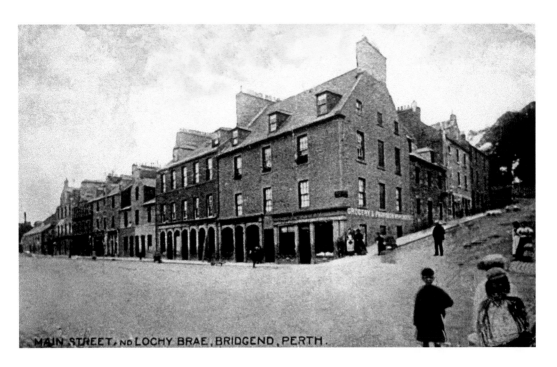

MAIN STREET, ND LOCHY BRAE, BRIDGEND, PERTH.

Bridgend Main Street

The enduring quality of parts of Perth is reflected in these relatively unchanged images of Bridgend Main Street, which are separated by over 100 years. Bridgend was a busy ferry crossing and the base of ferrymen who worked on the river before Smeatons' Bridge opened in 1771. There was a settlement at Bridgend from at least the sixteenth century, although the Statistical Account of Scotland (1791–99) notes that 'before the new bridge was built, Bridgend was a poor paltry village'.

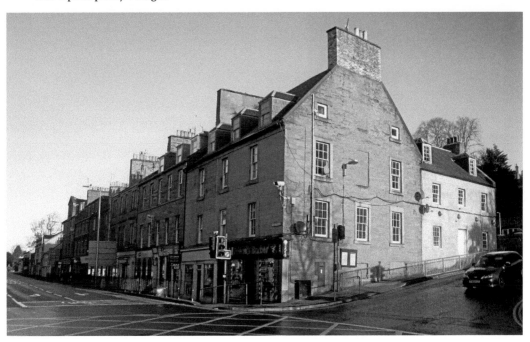

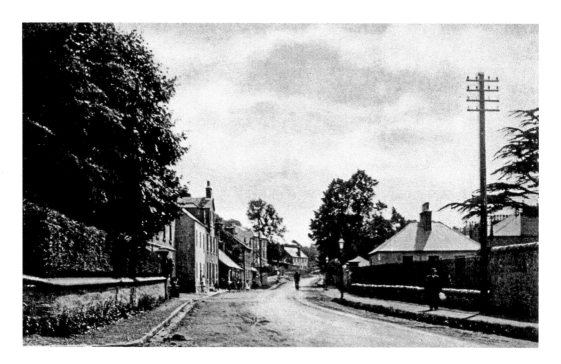

Barnhill

These views are looking south on the Dundee Road at Barnhill, just to the south of Fairmount Road. The buildings on the left side of the road in the older image are relatively unchanged, although there has been significant redevelopment on the other side of the road. It would also now be a little dangerous to walk in the middle of the road, which is the busy main Dundee Road. The villages, such as Barnhill, on the east bank of the Tay were relatively isolated from the town until Smeaton's Bridge was built in the 1770s. Barnhill developed substantially from a small number of sparse cottages when the new Perth to Dundee turnpike road opened in 1829.

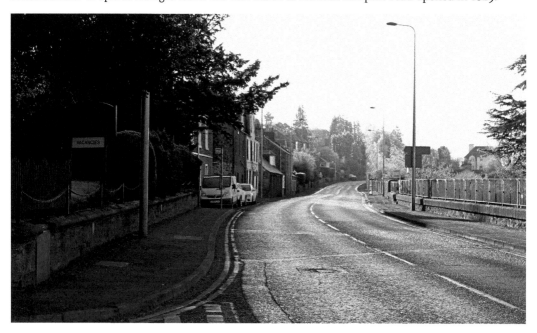

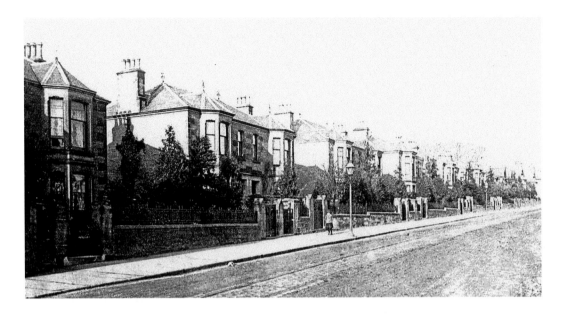

Pitcullen Crescent

Views of the substantial Victorian villas on Pitcullen Crescent that line the approach to Perth from the north. Pitcullen was an ancient barony of Perth held by the Earl on Kinnoull. The ornamental iron railings at the front of the houses would have been removed for the war effort in the 1940s. There is some debate about what happened to them after they were removed. It is claimed that the metal was unsuitable for reprocessing and was dumped at sea. There are stories that there was so much offloaded in parts of the Thames that the vast quantity of iron disrupted ships' compasses. It is also claimed that they were used as ballasts in ships – with many houses in African seaports being festooned with fine ornamental railings salvaged in the destination ports. The removal of so much ornamental metalwork was a great architectural loss; however, even if they never became guns and tanks it was seen as a morale-boosting exercise.

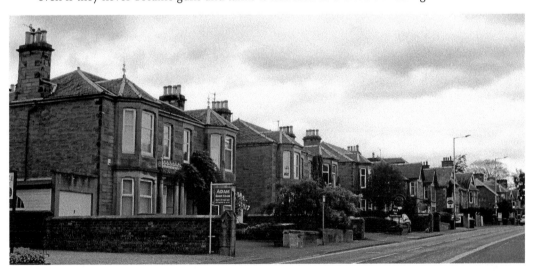

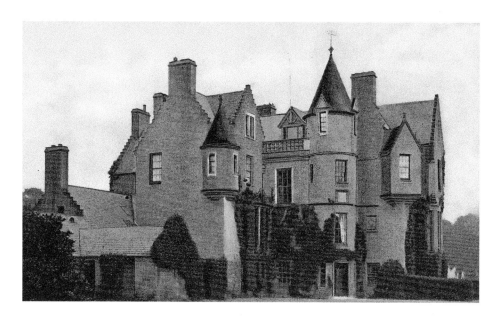

Balhousie Castle, Hay Street

Balhousie Castle has its origins in a twelfth-century castle owned by the Earls of Kinnoull. The current building is an 1860s Baronial-style remodelling of a later seventeenth-century tower house. Over the centuries the castle has been occupied by a number of eminent Perth families. From 1926 until 1940, the building was in use as a convent. During the Second World War, and for some time after, it was used by the army. In 1962, the castle was converted into the Regimental Museum of the Black Watch, which tells the story of Scotland's oldest Highland Regiment.

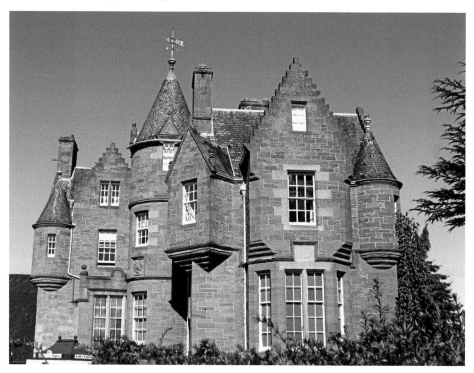

Poppies: Weeping Window at Balhousie and the Queen's Barracks

Between June and September 2016, Balhousie Castle hosted the *Poppies: Weeping Window* sculpture. The stunning cascade of thousands of handmade ceramic poppies from the second-floor turret window at the castle formed a poignant commemoration of all those who died in the First World War. Many thousands of Black Watch soldiers were killed or wounded during the First World War and it is appropriate that the sculpture was displayed at Balhousie, which is a focal point for remembrance of this and other conflicts.

The Black Watch Regiment has a long association with Perth. The Queen's Barracks were built in 1792 and occupied a large site to the west of St Ninian's Cathedral. The barracks served as the depot for the Black Watch from 1830 until 1961. The barracks were demolished and the site was redeveloped for the new police headquarters, the inner ring road and a sheltered-housing complex.

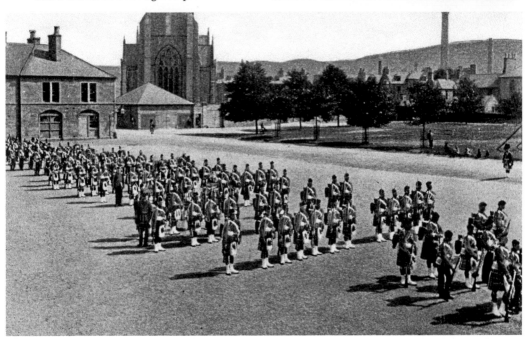

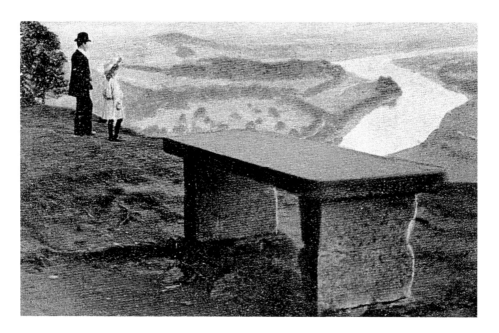

Kinnoull Hill

> The stupendous ridge of rock, called the Hill of Kinnoull, rising to the height of more
> than six hundred feet nearly perpendicular from the river, and other heights, contributes
> greatly to adorn the landscape, and, being mostly planted, forms a shelter and ornament
> of no common description.
>
> (*Views of the Seats of Noblemen and Gentlemen*, JP Neale, 1828)

The walk to the top of Kinnoull Hill is rewarded by magnificent views over the River
Tay and beyond from the steep south-facing summit. The name Kinnoull is derived from
the Gaelic meaning the head of the rock. Kinnoull Hill is the highest of the five hills that
make up the Kinnoull Hill Woodland Park. The others are Corsie Hill, Deuchny Hill, Barn
Hill, and Binn Hill. Kinnoull Hill was gifted to the city of Perth in 1924 and was officially
recognised as Scotland's first woodland park in 1991.

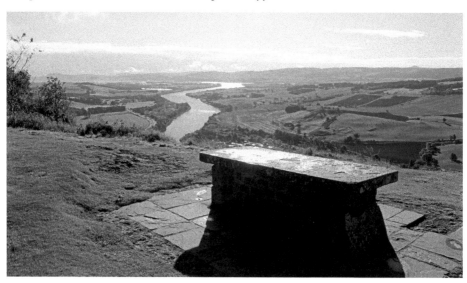

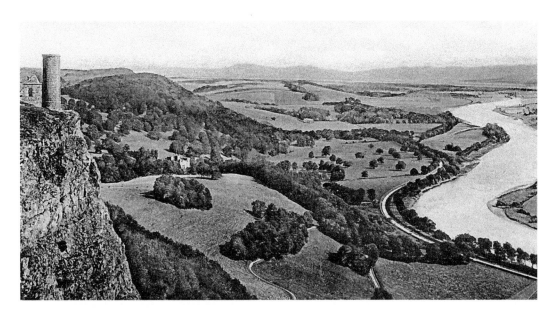

Kinnoull Tower

The picturesque Kinnoull Tower is a romantic folly on the edge of a dramatic rocky outcrop and forms a major local landmark. It was built by 1829 by Lord Gray of Kinfauns, who had been inspired by castles perched on hills in the Rhine Valley. Lord Gray was also responsible for the Binn Hill Tower and the stone table in the previous images.

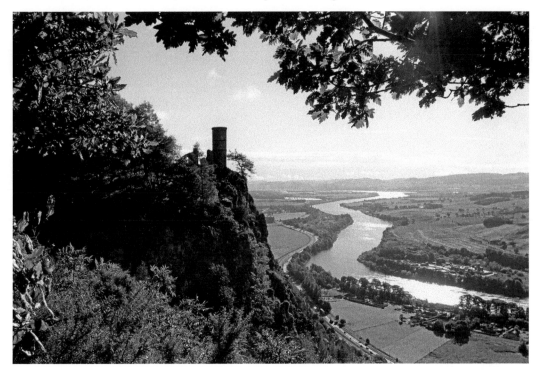

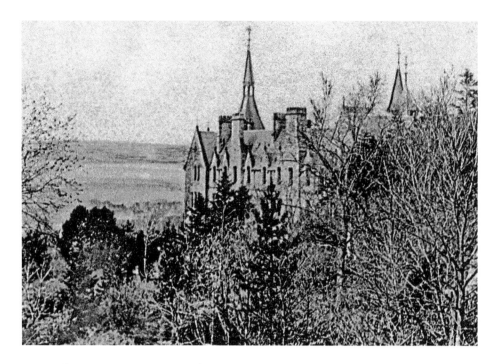

St Mary's Monastery, Hatton Road

St Mary's Monastery, on the wooded slopes of Kinnoull Hill, was built in 1868–70 as the base for the the congregation of the Most Holy Redeemer (the Redemptorist Order) in Scotland and is used as a monastic house and ecumenical religious retreat. The building was designed by local architect A. G. Heiton in a rather austere Gothic style. It was the first Roman Catholic monastery to be constructed in Scotland since the Reformation.

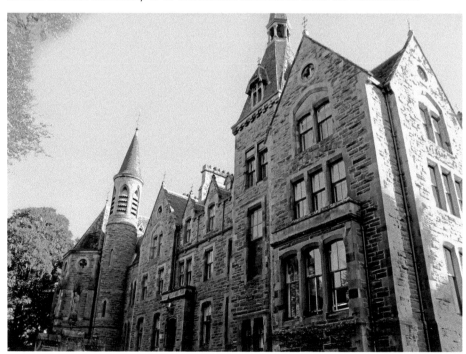

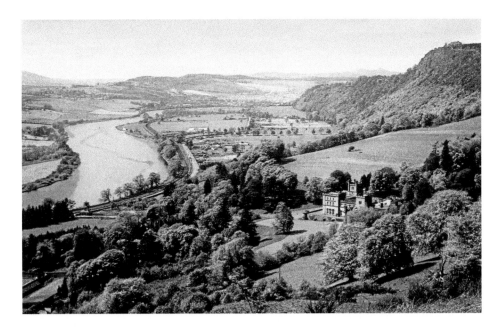

Kinfauns Castle

The situation of Kinfauns Castle is one of singular and romantic grandeur. From its elevation above the plain, there is an extensive and magnificent prospect of the Carse of Gowrie, the Hills of Fife, and the course of the Tay for many miles.

(*Views of the Seats of Noblemen and Gentlemen*, JP Neale, 1828)

Kinfauns Castle is a large castellated mansion with a central flag tower on a raised terrace on the edge of Kinnoull Hill, approximately 2 miles (3km) east of Perth. It dates from the 1820s and was designed by Sir Robert Smirke for Lord Gray on the site of an earlier medieval stone fortress. The building remained in the ownership of the Gray family until 1930. The estate was then sold off in lots and became a hotel for a time. It has been under private ownership since 2004.

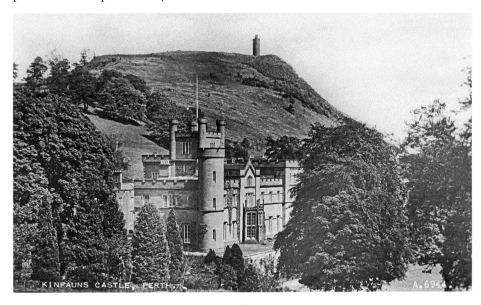

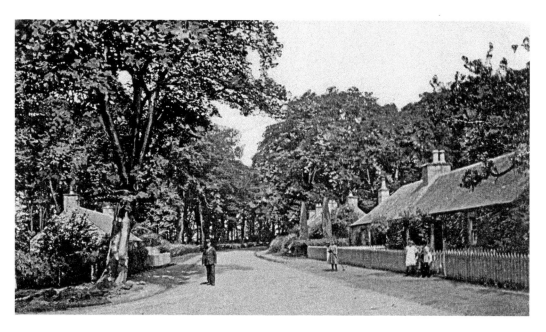

Old and New Scone

The old village of Scone was removed to allow the remodelling of the palace and layout of the policies in the early 1800s. The Scone Mercat Cross is almost all that remains of the old village. In 1805, the inhabitants were moved just over a mile east of the old village to the newly constructed planned settlement of New Scone.

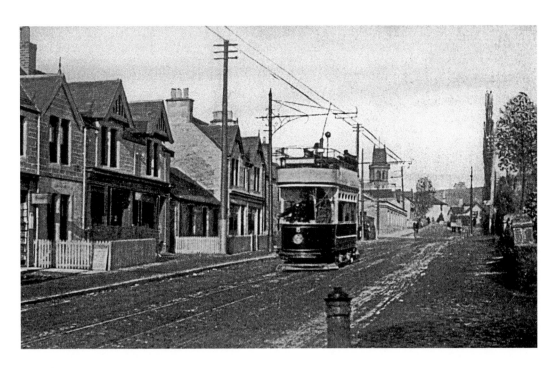

Scone

Scone was served by horse-drawn buses that were taken over by the Perth and District Tramways Co. in the 1890s; the electric tramway was opened in 1905. The maximum speed permitted was 12 mph, but a rather racy 16 mph was allowed on the straight run between Perth and Scone. The village was known as New Scone until 1987; since then it has been officially just Scone. Scone New Church with its distinctive tower, which can be seen in the background of the images, dates from 1887.

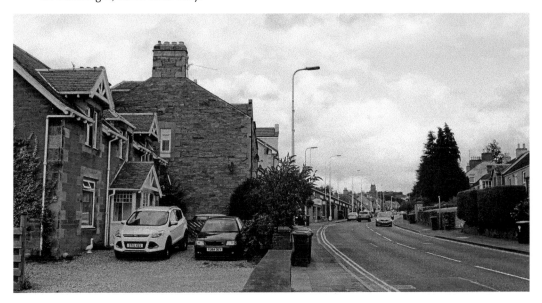

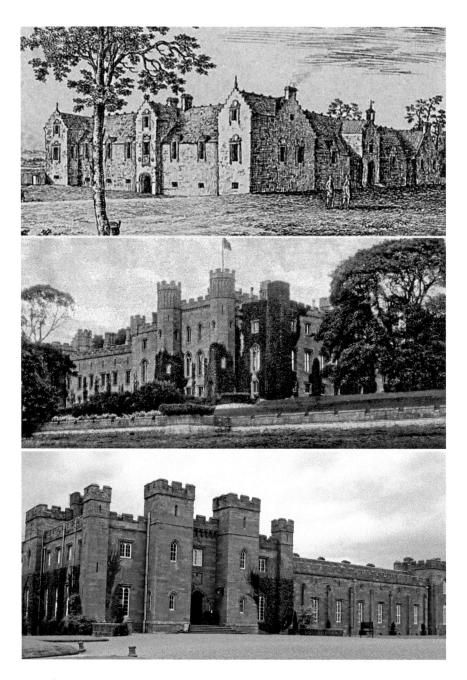

Scone Palace

Scone Palace is situated on a site with ancient historical connections. The Augustinian Priory and Bishop's Palace founded by Alexander I in 1120 were destroyed by a mob in 1559, following John Knox's rabble-rousing sermon at St John's Kirk. A new house was built by the Gowrie family in 1580. However, following the events of the Gowrie Conspiracy, James VI gifted the house to Sir David Murray as a reward for his loyalty. The house was remodelled in the early 1800s as a castellated mansion in the Gothic style with a profusion of picturesque battlemented towers and parapets by William Atkinson for William, 3rd Earl of Mansfield. The core of the building is the sixteenth-century house.

Moot Hill

'The ancient kingdom of Scone will always bulk largely in Scottish history.'

(Perth, the Ancient Capital of Scotland, Samuel Cowan, 1904.)

Moot Hill in the grounds of Scone Palace was the ancient site of the coronation of Scottish kings. The tiny mausoleum of the Earls of Mansfield is an 1807 remodelling of the original early seventeenth-century building. A replica of the Stone of Destiny, which was the emblem of sovereignty for Scottish monarchs, stands outside the chapel. There are numerous legends that surround the stone – one claims that it was Jacob's Pillow. It was brought to Scone by Kenneth MacAlpin in AD 843, confiscated and integrated into the throne at Westminster Abbey at the end of the thirteenth century, stolen by nationalists in 1950, recovered and returned to Westminster Abbey and then moved to Edinburgh Castle in 1996 due to a nationalist campaign. Recent analysis of the stone has shown that it was quarried close to Scone and that it is possibly a fake, substituted by the Scots for the original to hoodwink the English when it was removed at the end of the thirteenth century.

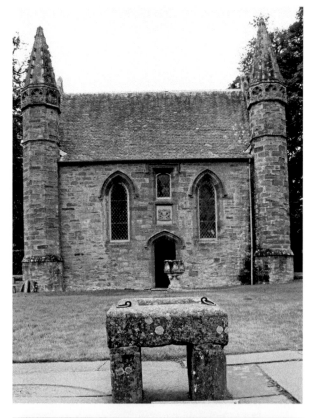

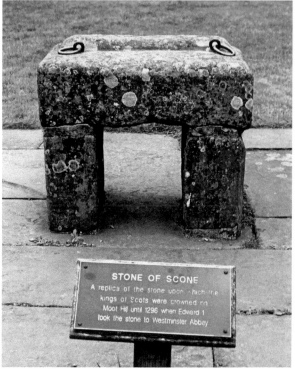

STONE OF SCONE
A replica of the stone upon which the kings of Scots were crowned on Moot Hill until 1296 when Edward 1 took the stone to Westminster Abbey

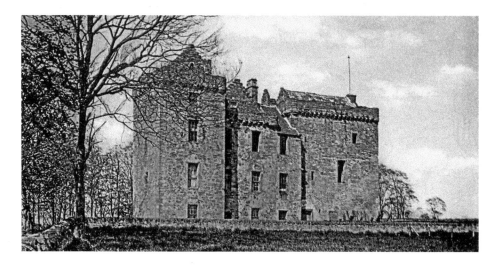

Huntingtower Castle

Huntingtower Castle was built by the Ruthven family and was originally known as the Place of Ruthven. It was built as two tower houses: the eastern dating from the fifteenth century and the western from around 1500, which were later joined to form a single castle. The closeness of the two towers is due to the division of the land between two of the Ruthven brothers.

Queen Mary visited in 1565 with Lord Darnley. The castle was also involved in plots by the Ruthven's against James VI, who was held prisoner for ten months at the castle in 1582. In 1600, the estate was confiscated by the Crown after the events of the Gowrie House Conspiracy and the castle was renamed Huntingtower. The castle remained in the possession of the Crown until 1643, when it passed to the Murrays of Tullibardine. It fell into general neglect in 1767 and was taken into state care in 1912.

The distance between the two towers at Huntingtower is around 9 feet and is known as the Maiden's Leap. This is based on the legend that Dorothea, the daughter of the 1st Earl of Gowrie, jumped between the two towers to avoid being discovered by her mother in a liaison with her lover.

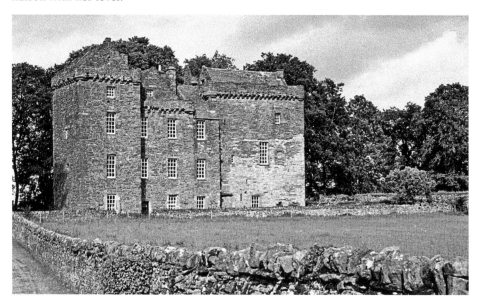